LIFELIKE
DRAWING
with LEE HAMMOND

Lee Hammond

NORTH LIGHT BOOKS
CINCINNATI, OHIO
www.artistsnetwork.com

about the author

the author

Polly "Lee" Hammond is an illustrator and art instructor from the Kansas City area. She owns and operates a private art studio called Take It To Art,★ where she teaches realistic drawing and painting.

Lee was raised and educated in Lincoln, Nebraska, and she established her career in illustration and teaching in Kansas City. Although she has lived all over the country, she will always consider Kansas City home. Lee has been an author with North Light Books since 1994. She also writes and illustrates articles for other publications such as *The Artist's Magazine*.

Lee is continuing to develop new art instruction books for North Light and has also begun illustrating children's books. Fine art and limited-edition prints of her work will also be offered soon. Lee lives in Overland Park, Kansas, along with her family. You may contact Lee via e-mail at Pollylee@aol.com or visit her website at www. LeeHammond.com.

★Take It To Art is a registered trademark for Lee Hammond.

Lifelike Drawing with Lee Hammond. Copyright © 2005 by Lee Hammond. Printed in Singapore. All rights reserved. No part of this book may be reproduced in any form or by any electronic or mechanical means including information storage and retrieval systems without permission in writing from the publisher, except by a reviewer who may quote brief passages in a review. Published by North Light Books, an imprint of F+W Publications, Inc., 4700 East Galbraith Road, Cincinnati, Ohio, 45236. (800) 289-0963. First Edition.

Other fine North Light Books are available from your local bookstore, art supply store or direct from the publisher.

11 10 09 08 07 8 7 6 5 4

Library of Congress Cataloging in Publication Data
Hammond, Lee., 1957–
 Lifelike drawing with Lee Hammond / Lee Hammond.
 p. cm
 Includes index.
 ISBN-13: 978-1-58180-587-1 (pbk. : alk. paper)
 ISBN-10: 1-58180-587-X (pbk. : alk. paper)
 1. Pencil Drawing—Technique. I. Title.

NC890.H28 2005
741.2'4—dc22 2004056093

Edited by Mona Michael
Cover design by Terri Eubanks
Interior design by Barb Matulionis
Production coordinated by Mark Griffin

F+W PUBLICATIONS, INC.

Metric Conversion Chart

To convert	to	multiply by
Inches	Centimeters	2.54
Centimeters	Inches	0.4
Feet	Centimeters	30.5
Centimeters	Feet	0.03
Yards	Meters	0.9
Meters	Yards	1.1
Sq. Inches	Sq. Centimeters	6.45
Sq. Centimeters	Sq. Inches	0.16
Sq. Feet	Sq. Meters	0.09
Sq. Meters	Sq. Feet	10.8
Sq. Yards	Sq. Meters	0.8
Sq. Meters	Sq. Yards	1.2
Pounds	Kilograms	0.45
Kilograms	Pounds	2.2
Ounces	Grams	28.3
Grams	Ounces	0.035

dedication

This book is dedicated to the many artists who buy my books, attend my workshops and classes, and continue to warm my heart with their many e-mails and letters. I feel so fortunate to have the number of fans that I do. I thrill in the knowledge that I am inspiring fellow artists and helping them reach their artistic goals. Art is such a wonderful gift, and I encourage you to share your talents and joy with everyone around you.

acknowledgments

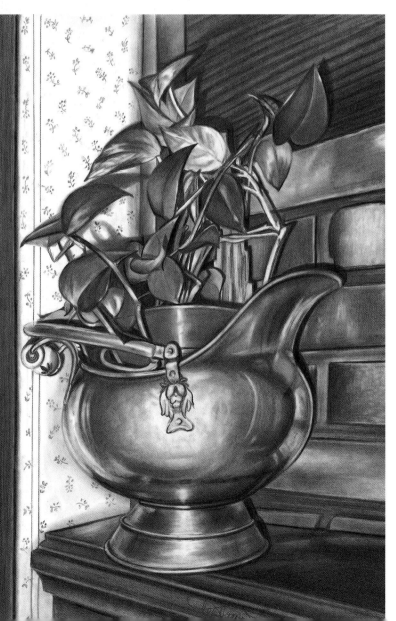

As always, I want to thank the many people who seem to find unwavering patience as I meet my deadlines. My family is incredible in the way they understand the stress and long hours involved. I love and appreciate them for the help and support that they offer me every day.

I also want to thank my students, who keep me continually laughing and inspired. None of this would make sense without you!

I would like to thank Peter Wellenberger for allowing me the honor of drawing from his mother's photos. She was a gifted and talented artist, and her beautiful work will now continue on through me.

I want to extend a heartfelt thank-you to my editor, Mona Michael. Her patient guidance, wonderful ideas and kind spirit have helped me create what may be my best book ever. Writing a book is a team effort, and I couldn't ask for a better group of professionals to go to bat with! And to everyone at North Light Books, a very special thank-you. You all make me feel like family, treat me like royalty and continue to indulge my endless book ideas. I couldn't be luckier!

Surfaces and Textures
Graphite on smooth two-ply bristol paper
14" x 11" (36cm x 28cm)

table of contents

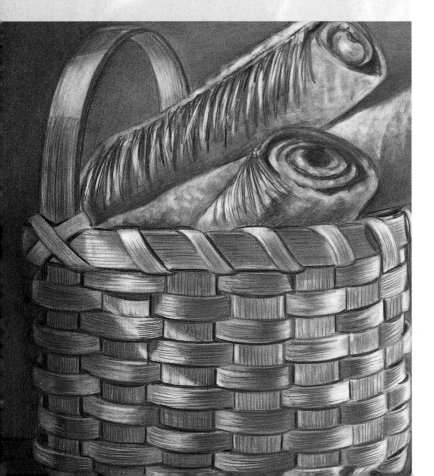

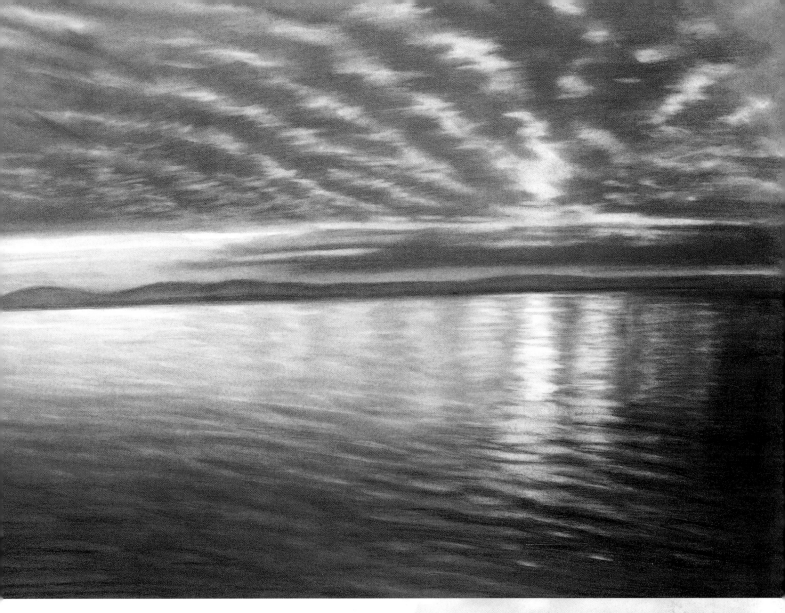

This book is a dream come true.

It has been in the back of my mind for many years. I love to draw. And I love to draw everything!

It is a complete drawing guide for learning how to draw anything. It takes the practical information from my other books and applies it to all kinds of subject matters. It could easily be considered a "Drawing Bible" and is the ultimate reference guide for all artists, to create any subject matter.

By studying the following pages and using the step-by-step demonstrations, you will learn how to draw everything using the same approach. Allow me to be your guide!

Once you learn that basic shapes exist in everything and how to use the five elements of shading to create realism and form, you'll be ready to draw anything you can think of. Landscapes, plant life, water and skies, transparent glass, metallic surfaces, bricks and fabrics, as well as people—no drawing subject will be beyond your reach.

You'll learn the benefits of graphing and segment drawing as a way of drawing what you see, as opposed to what you know. Whether you are drawing a single subject or an entire scene, this technique alone is invaluable.

With this book, you will see how to accurately depict anything you want in your drawings. The sky is the limit. Your photo albums will never look the same to you. They will go from simply being a book of memories to becoming an endless storehouse of subject matter and creative opportunities!

Shelly
Graphite on two-ply smooth bristol paper
17" x 14" (43cm x 36cm)

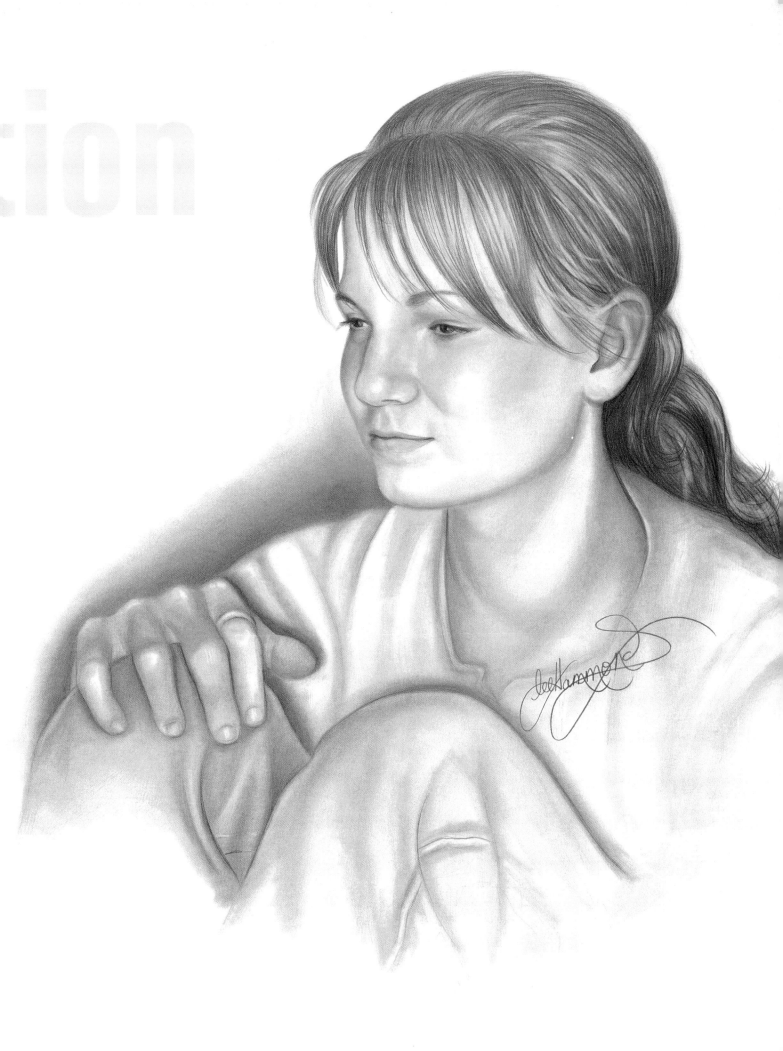

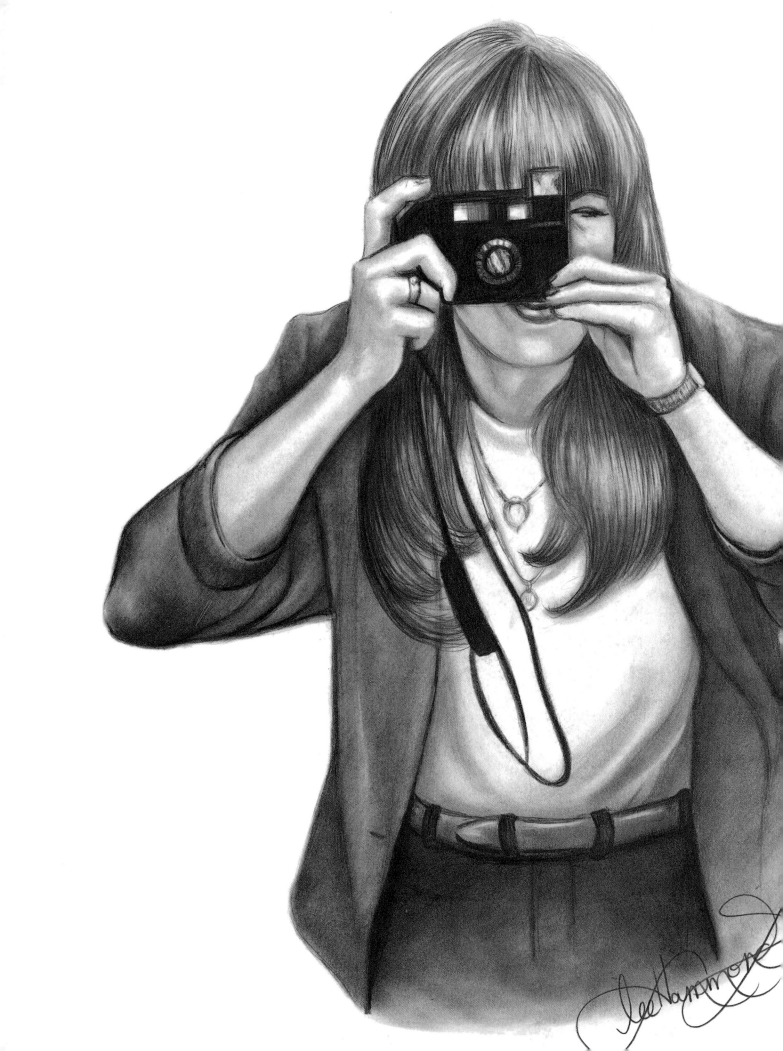

You Can Do It!

No one begins a new skill at full potential. Anything we learn has a beginning and gradually grows into something more. Artwork is no different. We all go through various stages of skill progression, each level suitable for the stage of learning that we are in at that moment. And learning never ends.

In my studio, classes and workshops, my students are a constant reminder of this. Each one is different, with different skills, strengths and desires. All of them are visual, so I demonstrate as much as I can. Showing is a much better teacher than telling. That's why I write the way I do, with many dissected examples and step-by-step exercises.

Anyone can become a proficient pencil artist by following this instruction with determination. The next few pages feature examples of the types of success stories that come out of my classes every day. You can do it, too!

Say Cheese!
Graphite on two-ply smooth bristol paper
14" × 11" (36cm × 28cm)

Before and After

The following examples were created by beginning students. All were new to drawing and had no formal art education before coming to my classes. They all advanced quickly once they learned to capture *shapes*, *lights* and *darks*.

The first drawings in each example bear strong similarities. This approach is typical of the way most people draw at the beginning stages of artistic development. They use hard outlines to define their subject's shapes, and any tones look choppy and uneven. Most beginners also struggle with proportion and shape.

All the students improved tremendously. Their drawings looked more realistic once they learned to capture accurate shapes and developed their use of controlled blending.

Follow the exercises to come and you'll uncover the mystery of realistic drawing, too.

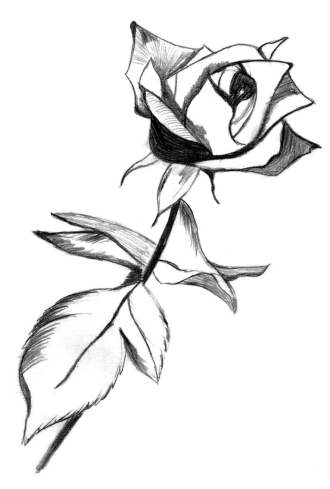

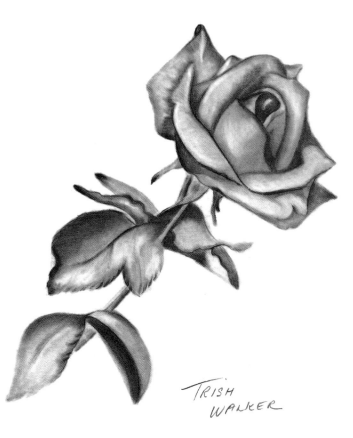

Before

Most drawings can be greatly improved just by increasing the contrasts; however, midtones or halftones are crucial to bridge the light and dark tones. This drawing lacks the subtle halftones that bring realism to drawings. It looks more like a quick sketch than a finished drawing and is too outlined to appear real.

Artwork by Trish Walker

After

She's gained a lot more control of her pencil in this piece. The smooth blending and added halftones give this piece a much more polished and professional look.

Artwork by Trish Walker

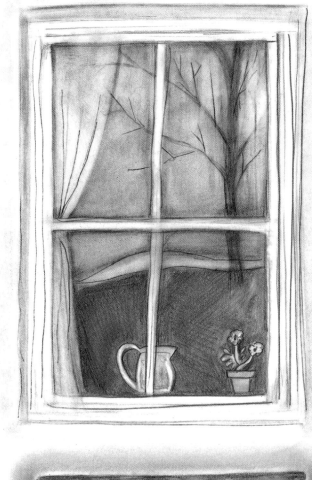

Before

The problem areas in this drawing are easy to see. The freehand lines are crooked and uneven. Straight lines are an important ingredient when drawing architectural structures. Also, the hard lines around everything give the scene a less realistic appearance.

It's pretty good for a young artist and needed just a few corrections and a little fine-tuning to make it better.

Artwork by Joanne deJongh

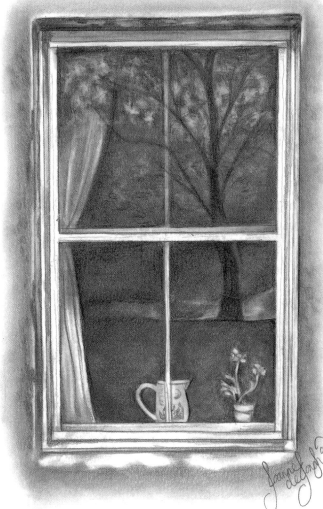

After

Compare this to the previous drawing and you will see how small corrections can make big differences. By simply using a ruler to straighten the edges of the window, everything seems more accurate. The blending softens the use of line, making the drawing appear more realistic.

Artwork by Joanne deJongh

Before

This still life is another good first attempt. The student captured the shapes but the proportions were off, causing the drawing to lack proper perspective. The shading and texture, is a little harsh to look realistic.

Artwork by Stephanie Larson

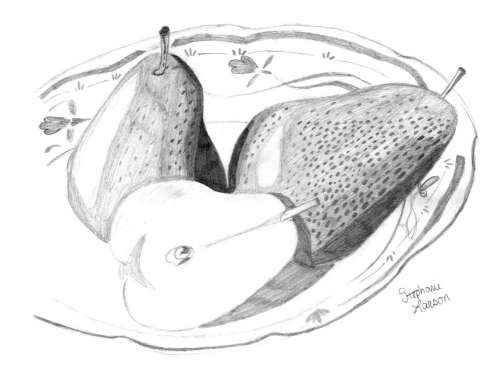

After

Using a projector, I showed her how to see the roundness of the bowl more accurately. The result is a more realistic view of the bowl as seen from this angle. By adding well-blended halftones and softening tones such as the speckles on the pear, the shading is more realistically captured. The entire drawing has gained depth.

Artwork by Stephanie Larson

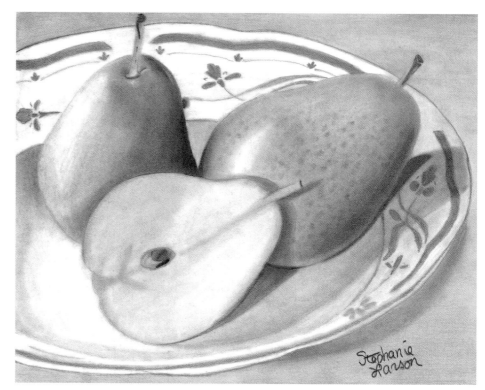

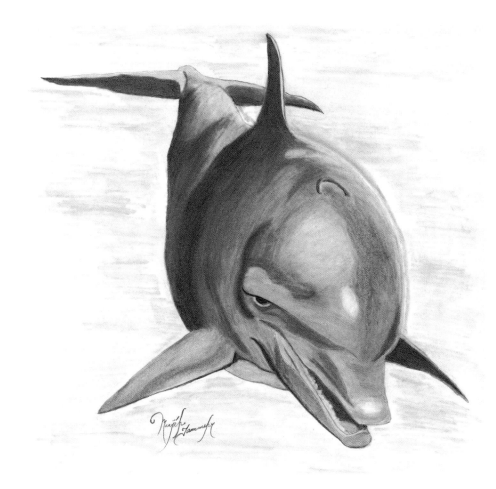

Before

When a drawing is a simple outline, it appears flat and unrealistic, much like a cartoon. The outline creates the basic shape of the dolphin, but the form is less apparent.

Artwork by Manijéh Tammehr

After

Shading instead of heavy outlining makes this drawing much more realistic. The various tones create a believable depiction of the dolphin and the true colors of its body. Also notice how much more accurate the proportions appear to be. By using the graphing techniques you'll learn in the next chapter, the proportions are better, giving the drawing more depth and the shape of the dolphin more realism.

Artwork by Manijéh Tammehr

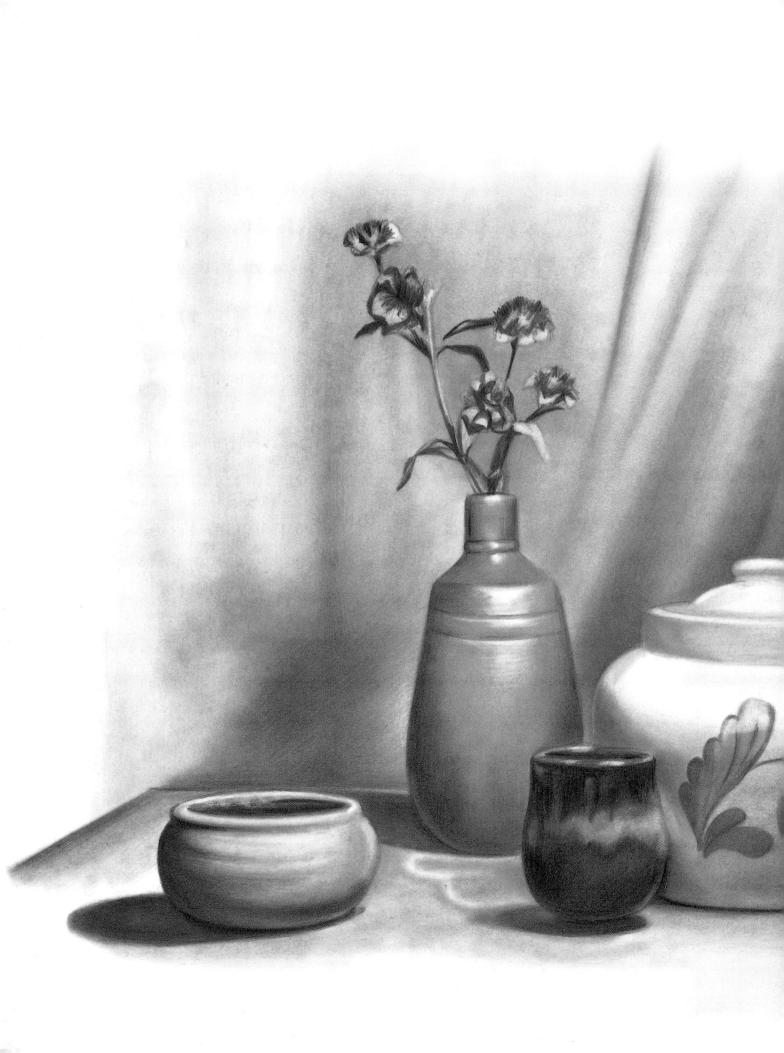

Techniques

Drawing is a highly personal statement. It combines each artist's personal experiences, education and personality. There are no absolutes in the artistic process. Each creation is highly unique and each approach different. While some artists embrace a loose, impressionistic style, I focus on the highly polished look of subtle tones and realistic drawing.

The two keys to this style are shapes and blending. Break down everything you want to draw into shapes, lights and darks. Training your eye to see this way won't happen overnight, so we will begin slowly, one element at a time. Once you learn to see subject matter as shapes, your accuracy will immediately improve. I will show you how.

But the most important key to this technique is *blending*. Blending, or the smooth application of tones from very dark to very light, will make any shape you draw appear more realistic. The blending should be so gradual that you can't tell where one tone ends and the other begins. We'll talk about where and how shading should be placed and blended, and I'll share with you the secrets behind my technique!

chapter two

Finished Still-life Study
Graphite on smooth two-ply bristol paper
11" × 14" (28cm × 36cm)

Materials for Working in Black and White

You cannot create quality artwork with inadequate art materials. My blended-pencil technique requires the right tools to create the look. Don't scrimp in this department or your artwork will suffer. I have seen many of my students blame themselves for being untalented when it was their supplies keeping them from doing a good job. The following tools will help you be a better artist.

Smooth Bristol Boards or Paper—Two-Ply or Heavier

This paper is very smooth (plate finish) and can withstand the rubbing associated with a technique I'll be showing you later in the book.

5mm Mechanical Pencils With 2B Lead

The brand of pencil you buy is not important; however, they all come with HB lead—you'll need to replace that with 2B lead. These pencils are good for fine lines and details.

Blending Tortillions

These are spiral-wound cones of paper. They are not the same as the harder, pencil-shaped stumps, which are pointed at both ends. These are better suited for the blended-pencil technique. Buy both large and small.

Kneaded Erasers

These erasers resemble modeling clay and are essential to a blended-pencil drawing. They gently "lift" highlights without ruining the surface of the paper.

Typewriter Erasers With a Brush on the End

These pencil-type erasers are handy due to the pointed tip, which can be sharpened. They are good for cleaning up edges and erasing stubborn marks, but their abrasive nature can rough up your paper. Use them with caution.

A Mechanical Pencil and Blending Tortillions

Mechanical pencils are great for fine lines and details, and you never have to sharpen them. Tortillions are the secret to my whole technique, so be sure to buy several packs of large and small tortillions.

Horsehair Drafting Brushes

These brushes will keep you from ruining your work by brushing away erasings with your hand and smearing your pencil work. They will also keep you from spitting on your work as you blow away erasings.

Pink Pearl Erasers

These are meant for erasing large areas and lines. They are soft and nonabrasive, so they won't damage your paper.

Workable Spray Fixative

This is used to seal and protect your finished artwork. "Workable" means you can still draw on an area after it has been sprayed. It fixes, or sets, any area of your drawing, allowing you to darken it by building up layers of tone without disturbing the initial layer.

Drawing Board

It's important to tilt your work toward you as you draw to prevent the distortion that occurs when working flat. Secure your paper and reference photo with a clip.

Rulers

Rulers help you measure and graph your drawings.

Acetate Report Covers

Use these covers for making graphed overlays to place over your photo references. They'll help you accurately grid your drawings.

Circle and Ellipse Templates

These will help you create accurate circles and ellipses; make sure the templates have different-sized circles and ellipses.

Reference Photos

These are valuable sources of practice reference material. Collect magazine pictures and categorize them into files for quick reference. A word of warning: Don't copy the exact image; just use the images for practice. Many photographers hold the copyright for the work, and any duplication without their express permission is illegal. You avoid this issue altogether when you use your own reference photos (see page 156).

Pink Pearl Vinyl Eraser
This soft eraser is good for large areas and lines, and it won't damage your paper.

Typewriter Eraser
This eraser is good for stubborn marks, but use it with caution. The abrasive nature can damage your paper if you push too hard.

Horsehair Drafting Brush
This is a great brush to clean off any erasings.

The Five Elements of Shading

To draw realistically, you must understand how lighting affects form. There are five elements of shading that are essential to realistically depicting an object's form. If any of these elements are missing, your work will appear flat. However, with the correct placement of light and dark tones, you can draw just about anything.

But how do you know how dark is dark and light is light? Using a simple five-box scale of values can help you decide on the depth of tone. Each tone on the scale represents one of the five elements of shading.

1 Cast Shadow

This is the darkest tone on your drawing. It is always opposite the light source. In the case of the sphere, it is underneath, where the sphere meets the surface. This area is void of light because, as the sphere protrudes, it blocks light and casts a shadow.

2 Shadow Edge

This dark gray is not at the very edge of the object. It is opposite the light source where the sphere curves away from you.

3 Halftone

This is a medium gray. It's the area of the sphere that's in neither direct light nor shadows.

4 Reflected Light

This is a light gray. Reflected light is always found along the edge of an object and separates the darkness of the shadow edge from the darkness of the cast shadow.

5 Full Light

This is the white area, where the light source is hitting the sphere at full strength.

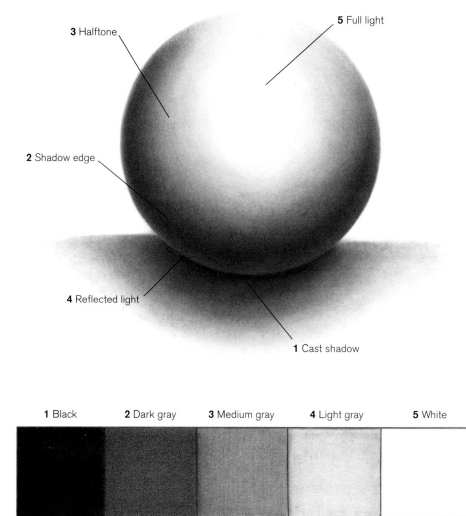

3 Halftone

5 Full light

2 Shadow edge

4 Reflected light

1 Cast shadow

1 Black	**2** Dark gray	**3** Medium gray	**4** Light gray	**5** White

Compare the Tones in the Value Scale to the Tones in the Sphere

Notice how the five elements of shading on the sphere correspond to the tones on the value scale. Look for the five elements of shading in everything you draw.

Create Smooth Blending

Proper shading requires smooth blending. To create smooth blending, you must first learn to use your tools and apply the pencil lines properly. If the pencil lines are rough and uneven, no amount of blending will smooth them out.

Apply your pencil lines softly and always in the same direction. Build your tones slowly and evenly. Lighten your touch gradually as you make the transition into lighter areas. Smooth everything out with a blending tortillion, moving in the same direction you used to place your pencil tone. Begin with the darks and blend out to light.

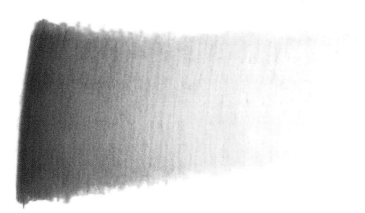

Incorrect Blending
This sample shows poor pencil application. The scribbled lines look sloppy, and a tortillion wasn't used for blending.

Keep Lots of Tortillions on Hand
Always use a fresh tortillion for the light areas. Don't be tempted to use the same ones over and over again to conserve. They are nothing more than paper wrapped into a cone shape and are inexpensive. I buy them by the gross so I never have to search for a clean one when I need it.

Hold Your Tortillion at an Angle
For even blending and to keep the end of your tortillion sharp, always hold it at an angle. If the end becomes blunt, poke a straightened paper clip through the top to straighten it out.

Correct Blending
Apply the lines closely, then, in an up-and-down fashion, fill them in. Add tone until you build up a deep black, then lighten your touch and gradually get lighter as you move to the right.

Blend your values with a tortillion using the same up-and-down motion you used with the pencil. You do not want to see clear distinctions between where one tone ends and the next begins. Lighten your touch as you move right and gently blend the light area into the white of the paper until you can no longer tell where it ends.

Practice Blending for Actual Objects

Before you beging drawing actual objects, you should get a good feel for your tools and materials. First draw some correct blended-tone swatches, as shown on page 19, to help you learn to control your blending. Start with your darkest tone on one side and gradually lighten the tone as you continue to the other side. Do as many as you need to until you feel proficient at it.

Once you begin to draw actual objects, use the following guidelines to help you.

1 Soft Edge
This is where the object gently curves and creates a shadow edge. It is not harsh, but a gradual change of tone.

2 Hard Edge
This is where two surfaces touch or overlap, creating a harder-edged, more defined appearance. Note: This does not mean outlined! Let the difference in tones create the edge.

3 Application of Tone
Always apply your tones, whether with your pencil or tortillion, with the contours of the object. Follow the curves of the object with the shading parallel to the edges so you can blend into the edge and out toward the light. It is impossible to control blending if you are cross-blending and not following the natural edges and curves.

4 Contrast
Don't be afraid of good, solid contrasts of tone. Always compare everything to black or white. Use the five-box value scale to see where the gray tones fit in. Squinting your eyes while looking at your subject matter obscures details and helps you see the contrasts better.

The sphere, the egg and the cylinder are all important shapes to understand. If you can master the five elements of shading on these simple objects first, drawing other things will be much easier.

Lee's lessons
Correct uneven tone by forming a point with your kneaded eraser and drawing in reverse. With a light touch, gently remove any areas that stand out darker than others. Use light strokes with your pencil to fill in light spots.

Practice Blending
Hone your blending skills on basic objects, like this cylinder, before moving on to more complicated forms. We'll talk more about cylinders in the next chapter.

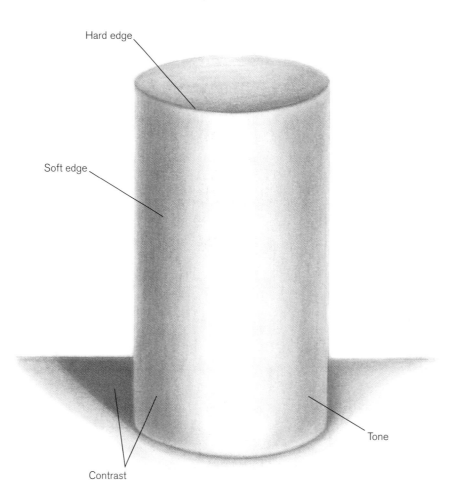

Hard edge

Soft edge

Contrast

Tone

Learn to See Basic Shapes

No matter how complex the subject, everything we draw is made up of basic underlying shapes. If you imagine a snowman, you immediately think of three spheres, one on top of the other. A table resembles a box or cube.

Before you learn to draw complex subjects, it's a good idea to learn to recognize their basic shapes. The basic shapes shown on this page—a sphere, a cylinder, a cone and a cube—are the basis of anything you draw, from trees to cars to people. Practice seeing these shapes in your surroundings. Visualizing these as you draw will help you accurately render your subject matter.

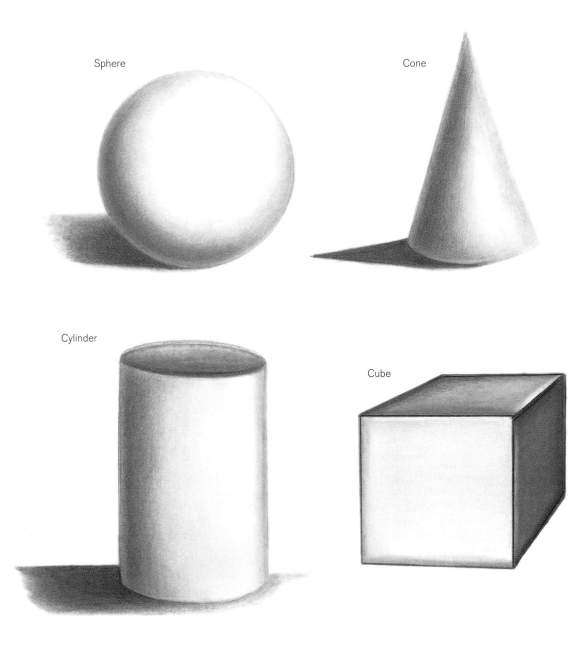

Sphere

Cone

Cylinder

Cube

Creating Lights

Have you ever noticed how, as children, we are taught to draw everything with a hard outline on white paper with no background? I used to actually get in trouble because I wanted to fill in the backgrounds.

Background tone is crucial to realistic drawing. It took me a long time as an adult to break the outlining habit. I did it, though, and so can you. Study the sphere shown on this page. The dark tone of the background makes the lights stand out. Let the darks create the lights. This rule applies whether you are creating a simple shape like the pictured sphere or something more complicated.

Realistic Drawing Shows Reflected Light

Reflected light is light captured on an edge, a rim or lip of an object. Look at any object near you right now, especially if it is in bright light. Look for the edges along the sides, the top or on raised surfaces. Can you see the light along those edges?

Now examine the drawing of the hat. The top of the hat shows the full light source reflecting along the edges. The brim of the hat also shows reflected light along the edges. If you look closely, even the hat band has some reflected light

because it is slightly raised off of the surface of the hat.

How to Lift the Light

We'll talk over and over in this book about lifting light areas. Do not think of it as erasing. Lifting the light is the process of drawing light back into the drawing. You can form the end of your kneaded eraser into a point to do this or sharpen the end of a typewriter eraser for an even finer line. Always think of lifting as drawing in reverse.

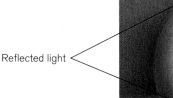

Light against dark

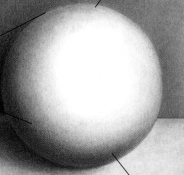

Reflected light

Dark against light

Darks Create Lights

It is the gradual change of light against dark turning into dark against light that creates realistic drawings. The background shading helps create the shape of the sphere. The dark background surrounding the top side of the sphere creates the light edges. There is no hard outline to define it. The dark edge of the sphere contrasts against the light of the table at the lower right edge.

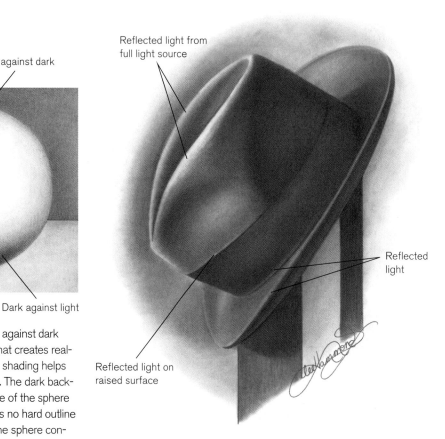

Reflected light from full light source

Reflected light

Reflected light on raised surface

Add Realism to Your Drawings With Reflected Light

Look for all the areas of reflected light along the edges and raised surfaces of this hat. Areas such as these can be lifted out with your kneaded eraser.

Three Steps to Draw Any Shape

All realistic drawing requires three basic steps. First is an *accurate line drawing,* which is basically a light outline of your subject matter as well as interior details. Second is the identification and placement of the *tones,* or lights and darks, followed by smooth and gradual *blending* for the final step.

Follow this demonstration closely and refer back to the value scale on page 18 to review a gradual blend. You may want to practice this demonstration two or three times. This may seem repetitious, but practice is the key to successful drawing. Everything you want to draw in the future will be directly related to this exercise.

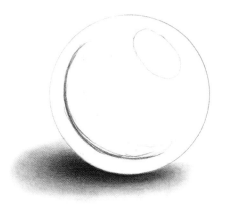

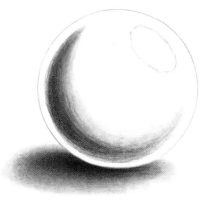

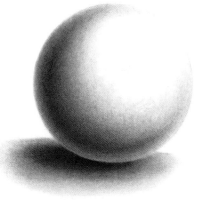

1 Create the Line Drawing and Place the Cast Shadow

Once you've accurately drawn the object's shape, identify the light source. Lightly outline the area on the object where the light shines the brightest. You'll erase those lines later. Place your cast shadow opposite your light source. You now have your lightest light and darkest dark.

2 Place the Tones

Place the shadow edge carefully. Apply your pencil lines smoothly, going with the shape of the object. Be sure to leave room for reflected light. Keep the shadow low, where it belongs. It can't be in the light area.

3 Blend the Tones

Use your tortillions to blend and create the halftones. Smoothly blend with the object's form from dark to light. Allow the tone to create the edge of the object and remove any outline that may be showing. Anything with an outline around it appears flat. Correct any uneven spots in your blending. Gently fill in light spots with your pencil and lift dark spots with a pointy piece of your kneaded eraser.

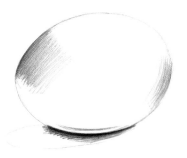

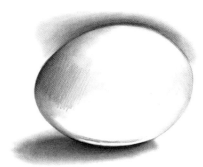

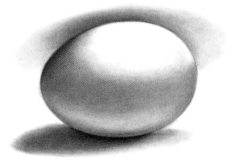

Draw a Cube

Drawing the cube is very different from drawing an egg or a sphere. Because of the flat surfaces, you will not see the five elements of shading the same way. Rounded objects feature gradual transitions of value, as you practiced previously. Each flat surface on an angular captures the light differently, making each side a different tone. Also, everywhere the surfaces meet an edge is created, which means reflected light.

Lee's lessons

There are just three steps to creating realistic drawings. You can draw anything using this system!

1 Capture the shape with a line drawing.
2 Apply the dark tones first.
3 Blend the halftones and lift the light.

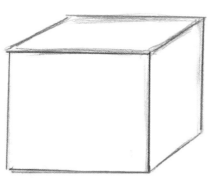

1 Create the Line Drawing

Begin with an outline of the basic cube. Lightly shade around the hard edges where the surfaces meet.

2 Place the Dark Tones

Decide where the light source will be and place the darkest tones. Since the cube's surfaces are flat, the tones will not be as gradual as the sphere's. Each plane's tone should be different, and the change will be more abrupt.

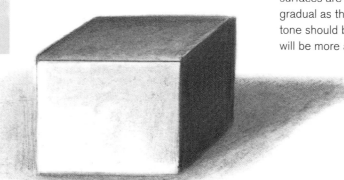

3 Blend the Halftones and Lift the Light

Blend all your tones. Use a dirty tortillion to add some tone to the light side. Remember to lift the reflected light off each hard edge. You still apply the five elements of shading to angular objects; your tonal changes are just more abrupt.

The Puzzle Piece Theory

Before you begin any type of blending on your artwork, it is very important to give yourself a firm foundation to build on. To do this, you need an *accurate line drawing*.

The easiest and most educational way to draw from photos is to use a graph. A graph is a tool that divides your subject into smaller, workable boxes to draw in. This exercise will help you understand how a graph works. It's fun, too, just like a puzzle!

On this page is a series of numbered boxes that contain black-and-white nonsense shapes. Draw these shapes in the corresponding numbered boxes on the empty graph on the next page. If you complete this exercise, you'll see that you *can* draw. You'll learn to see shapes. *Do not* try to figure out what you're drawing. As soon as we become aware of what the subject matter is, we tend to draw from our memories instead of from what is right in front of us.

No matter what you are drawing, concentrate on seeing the subject as many individual shapes, which interlock like a puzzle. If one of the shapes you're drawing doesn't lead to the next one, fitting together, you know that your drawing is inaccurate.

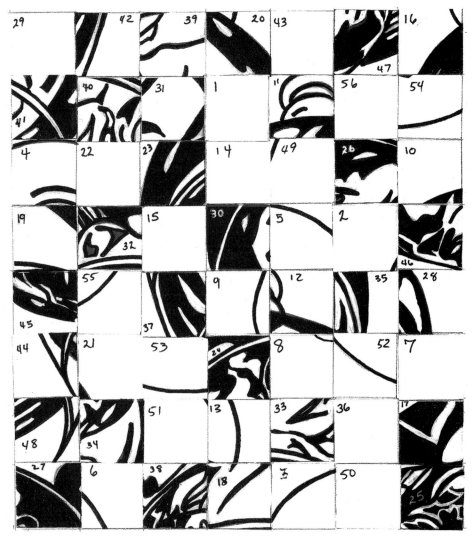

See All Subject Matter As Shapes

Look for the interlocking shapes within the tones and shapes of the object you are drawing. This exercise will show you how well you can draw, without even knowing what it is you are drawing!

Draw these nonsense shapes in the corresponding numbered boxes on the next page to reveal the drawing.

1	2	3	4	5	6	7
8	9	10	11	12	13	14
15	16	17	18	19	20	21
22	23	24	25	26	27	28
29	30	31	32	33	34	35
36	37	38	39	40	41	42
43	44	45	46	47	48	49
50	51	52	53	54	55	56

Solve the Puzzle

Make a copy of the empty graph, then draw the nonsense shapes exactly as you see them on the previous page. Be sure to draw each shape in its corresponding numbered box.

Use a Grid to Draw From Photos

Now that you are familiar with the puzzle piece theory and the box method of drawing shapes, you are ready to draw from photographs using a grid. Everything you want to draw can be broken down into manageable pieces similar to the shapes seen in the puzzle exercise. By placing a grid over your reference photo, you will create your own puzzle to work from.

There are two different ways to grid your reference photos. The first way (and the way I prefer) is to have a color copy made of your photo. A black-and-white copy may not give you enough clarity to work from. If the photo is small, enlarge it as well. Working from small photos is the biggest mistake most students make. The bigger the photo, the easier it is to work from.

Use a ruler to apply a one-inch or half-inch grid directly onto the copy with a permanent marker. Use the smaller grid if there is a lot of small detail in your photo. There is less room for error in the smaller box, so little things are captured easier.

If you do not have access to a copier and your photo is large enough to work from, you can place a grid overlay on top of the photo. Make your own grid with a clear report cover and a permanent marker, or have one printed from a computer on acetate sheets. Then simply place the premade grid over the photo and work from that.

Once you place the grid over the photo, the image becomes a puzzle and each box contains shapes. Look at everything you want to draw as just a bunch of interlocking shapes. To draw the photo,

draw a grid on your drawing paper with your mechanical pencil. Draw the lines so light you can barely see them, because they will need to be erased later. This grid should contain the same number of boxes as the one over the photo.

You can enlarge the size of your drawing by placing the smaller grid on your photo reference and making the squares larger on your drawing paper. For instance, if you use the half-inch grid on the photo and a one-inch grid on your paper, the image will double in size. Reduce the size of the drawing by reversing the process. As long as you are working in perfect square increments, the shapes within the boxes will be relative.

All the illustrations in this book can be drawn by placing an acetate grid over the examples.

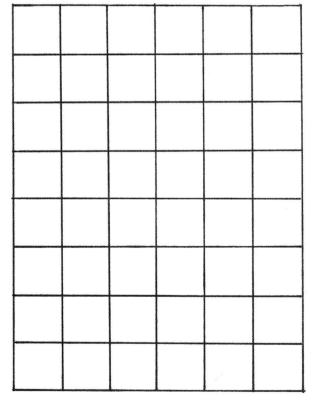

A Half-inch Grid

A One-inch Grid

Create a Line Drawing With a Grid

This exercise will show you how to draw from a graphed image. For now, don't worry about the tones in this photo; just concentrate on using the grid as a guide to capture the basic shapes in an accurate line drawing. Remember, you can increase the size of your drawing by drawing larger squares on your paper.

When you are finished, your line drawing should look like the one pictured. Keep your finished line drawing for the step-by-step demonstration on pages 38–39.

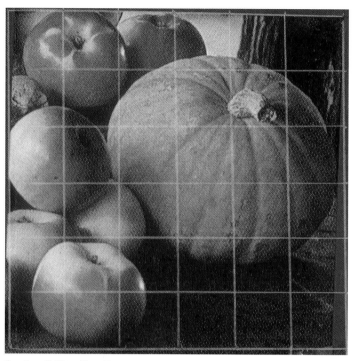

Create a Grid on Your Paper
On your drawing paper, lightly draw the same number of squares you see here.

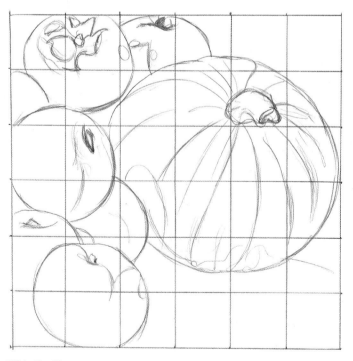

Fill In the Shapes
Working on one box at a time, capture the shapes you see in each box. Go slow and be accurate. The entire outcome of the drawing hinges on this stage of the game.

Draw Shapes With Segment Drawing

Now that you've learned a little bit about shading and seeing objects as shapes, you're ready to try segment drawing. This exercise will help you see even complicated subjects in simpler terms.

Hands are one of the most difficult things to draw well. Breaking them down into abstract forms with a viewfinder and concentrating on the shapes makes the task more manageable. This will also give you practice applying the tones, beginning with the darkest areas first. Look for the five elements of shading as you complete this demonstration.

1 Create the Viewfinder

Cut an opening in a piece of black construction paper to create a little frame, or viewfinder.

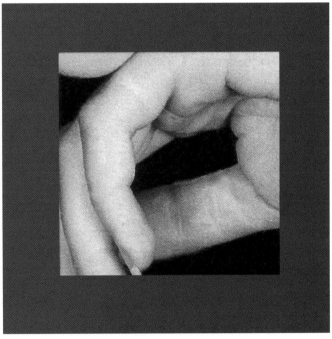

2 Place the Viewfinder Over a Photo

Place the viewfinder over a photo so only a small portion of the photo is revealed. This changes the photo from a recognizable composition into a collection of abstract shapes.

3 Create the Line Drawing

Create the same size box on your paper and draw only what you see inside the frame. If you need more guidance, draw a grid over the reference photo like you did before. Forget what the subject really is and just draw shapes as you see them. If you have trouble doing this, turn the photo upside down and draw it that way.

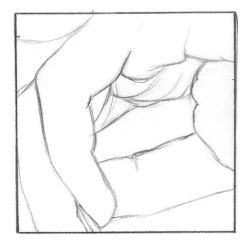

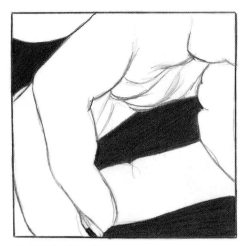

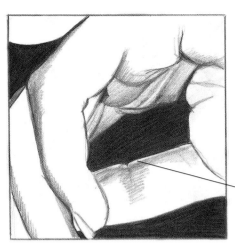

The shadow edge and reflected light meet.

4 Fill In the Darks

Always add your darkest tones first. The dark tones will create the light shapes of your drawing as well as the edges and shapes of the areas in the full light area.

5 Develop the Shadow Edges and Areas of Reflected Light

Once the dark tones are added, add the shadow edges to begin creating the form. Use the same procedure you used during the sphere exercise on page 23. Shadow edges create the illusion of roundness and curve.

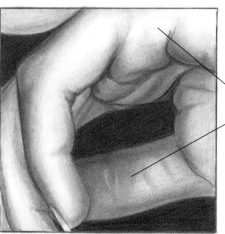

Compare tones to create distance.

6 Create the Halftones

Continue blending from dark to light. The halftones will begin to appear as you blend to the full light. Your halftones are all of your middle tones.

7 Blend the Tones to Create Distance

Blend your tones with the tortillion. Notice how the distance is created with the tones. Lighter tones appear closer, while darker tones appear farther away.

Using Your Viewfinder

To gain a lot of drawing practice without the feeling of being overwhelmed by large, finished projects, begin a segment drawing notebook. This is a page taken from one of mine.

Create a viewfinder with a two-inch opening. Go through magazine pictures to find interesting subjects to draw. Select pictures that will give you a variety of challenges and learning experiences.

Use some graphic border tape around each drawing for a cleaner-looking presentation. (This can be purchased in a variety of sizes from your local art store.)

Start your own segment drawing notebook as soon as possible and try to draw at least one image a day. You can do it. They are small exercises and don't take very long, but the experience you gain is huge!

things to remember

- Apply the five elements of shading to everything you draw.
- Use the five-box value scale to judge the depth of your tones. Compare everything to black or white.
- Keep your blending smooth and gradual.
- Always use your tortillion at an angle to keep the tip from collapsing.
- Look for the basic underlying shapes in everything you draw.
- Look for dark against light and light against dark.
- Always think of lifting as drawing in reverse.
- Anything with an outline around it will appear flat and cartoon-like.
- The cube's flat surfaces will capture light differently than a rounded object.
- Anything with a lip, an edge or a rim will have reflected light along those edges.
- Look in magazines for photos similar to those in this chapter and practice drawing them using the grid method.

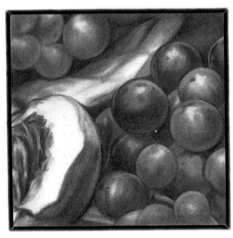

Practice with spheres and overlapping surfaces.

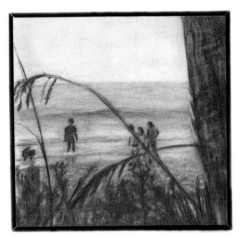

Practice creating distance.

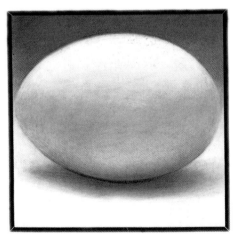

Practice with light against dark and dark against light.

Practice seeing a human being as just shapes, lights and darks.

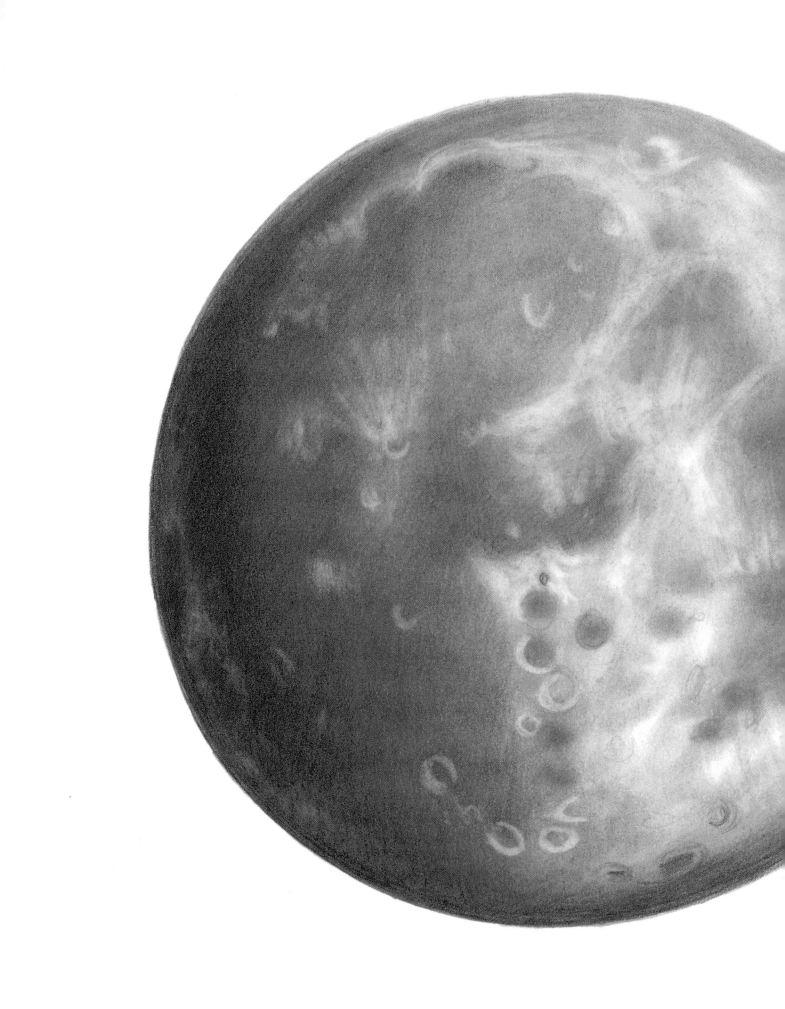

Rounded & Cylindrical Objects

To learn something new, it is always good to start with the easiest things first. When learning to drive, we practiced going back and forth in the driveway before we hit the interstate during rush hour! An experience such as that could be so traumatic, we might never want to drive again. The same theory applies to drawing. I've seen beginning artists dive right into very complex projects. Unfortunately, they usually quit drawing altogether, claiming it is just too hard!

So we're going to focus on the easier things first, like basic shapes. All you need to know to begin is how to draw a sphere and a cylinder. From these basic shapes you can create more complex rounded objects such as pumpkins, teapots and tree trunks.

The Moon
Graphite on smooth two-ply bristol paper
11" × 14" (28cm × 36cm)

Create Drawings From Basic Shapes

As we discussed before, an accurate line drawing is the foundation for all finished drawings. It describes the basic underlying shape of the subject. However, it is the rendering of the tones (darks and lights) that tells us what the real characteristics are and what the object is.

A sphere can be changed into many different objects just by changing the way you apply the tones. You'll find many everyday objects containing the sphere.

An Empty Shape
This line drawing is just an irregular sphere. However, by applying tones, you can change it into a finished drawing of many different objects.

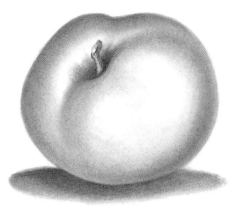

Toning Creates an Apple
With a little light shading and a stem, the sphere becomes an apple.

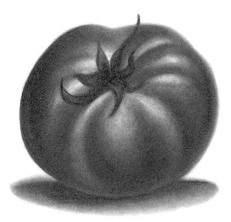

Toning Creates a Tomato
By deepening the tones, creating the illusion of surface indentations and changing the stem, the sphere becomes a tomato.

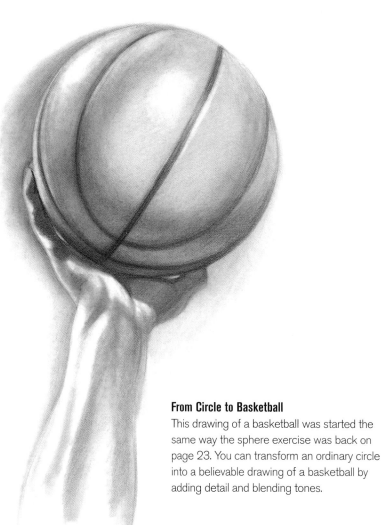

From Circle to Basketball
This drawing of a basketball was started the same way the sphere exercise was back on page 23. You can transform an ordinary circle into a believable drawing of a basketball by adding detail and blending tones.

Repeated Spheres Become Objects

Once you've practiced drawing a basic sphere, try connecting spheres to create more complex drawings. A string of pearls is a wonderful example of many connected spheres. Each sphere captures the five elements of shading differently because each is at a different angle to the light. That's why each pearl must be drawn separately. Note how the light and shadow affect each one. Drawing each shape separately will allow you to capture its individual nuances. There are no shortcuts to good drawing!

Repeat Your Sphere Exercises
Practice drawing repeated spheres like this string of pearls. Remember to include the five elements of shading for each pearl.

Full light

Halftone

Shadow edge

Reflected light

Cast shadow

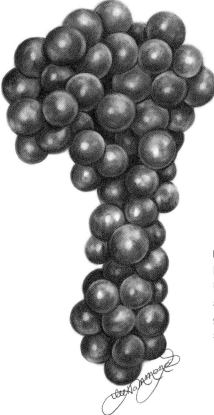

One Sphere at a Time
Draw each grape individually, just like the pearls. Use your kneaded eraser to lift the lights. Look at the grocery ads in your local newspaper for great resource photos of grapes and other spherical objects.

Draw a Pumpkin

This drawing contains all the elements you practiced in the sphere exercise, with the addition of some surface textures and indentations. The indentations in the pumpkin are caused by two surfaces coming in contact and creating a crease. Whenever two surfaces touch or overlap, they create a hard edge (see page 20). You will always see reflected light above a hard edge. A soft edge is created where the raised area gently curves and creates a smooth tone.

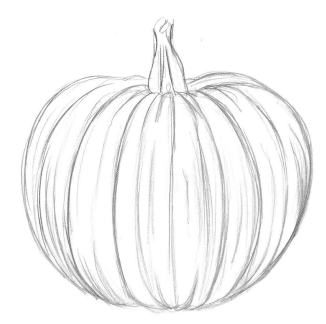

1 Create the Line Drawing

Lightly draw the outline of the pumpkin, along with the lines that divide the surface. Indicate the grooves in the pumpkin's surface with lines.

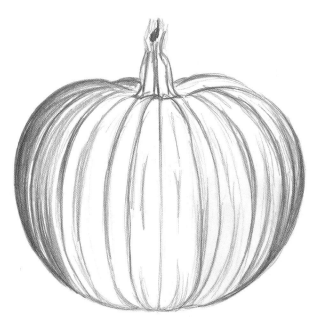

2 Add Some Darks

Start adding tone to the outside edges, remembering that the dark areas help create the shapes of the light areas. Place the dark tones to create all of the recessed areas of the pumpkin's surface, making the light areas seem to protrude. The shape and edge of the pumpkin will take form along the outside.

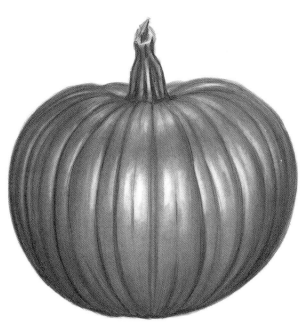

3 Fill In and Blend the Tones, Then Lift the Lights

Fill in the tones over all of the pumpkin. Make the tones at the band of light that encompasses the pumpkin at its roundest point, as well as reflected light against each ridge, the absolute lightest.

Blend the tones, then deepen the dark areas for more contrast and use the kneaded eraser to lift out areas of reflected light. Use the same process for the stem of the pumpkin. Remember, there's a smaller band of light on the stem.

Practice Hard and Soft Edges

The bell pepper is a rounded object like the sphere, but it contains irregular surface shapes like a pumpkin. The indentions and creases create hard and soft edges and alter the way the light reflects. You must include the five elements of shading in each raised area.

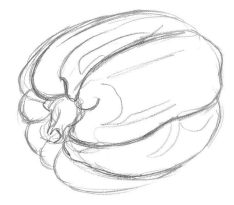

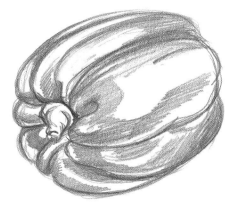

1 Create the Line Drawing

Use a grid to draw a pepper from a grocery advertisement in your newspaper or graph this drawing to create an accurate line drawing.

2 Create the Dark Tones

Add dark tones with the pencil to create form. Leave areas along the edges of each raised surface for reflected light. Consider each of the five elements of shading as you draw.

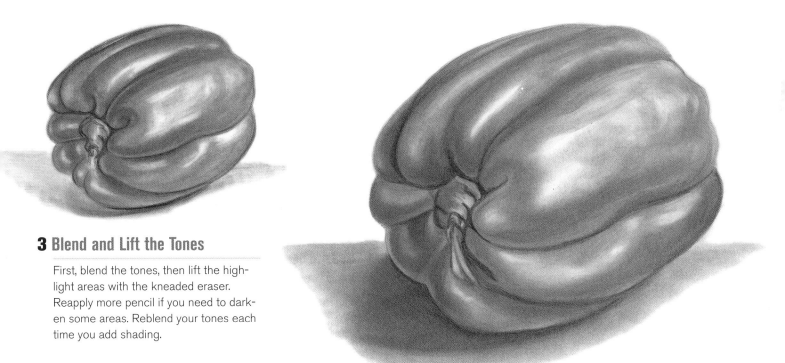

3 Blend and Lift the Tones

First, blend the tones, then lift the highlight areas with the kneaded eraser. Reapply more pencil if you need to darken some areas. Reblend your tones each time you add shading.

4 Finish the Pepper

Keep adding tone, blending and lifting light until you're satisfied with your drawing.

A Simple Still Life: Pumpkin With Apples

If you haven't completed the line draw-ing on page 28, go back and do that now. During this demonstration you will finish the pumpkin and apple drawing you began there.

This drawing is a segment drawing of a much larger scene. You can see how the viewfinder was used to create this composition. Since you now have some practice drawing a simple pumpkin in normal lighting, let's learn about the effects of extreme lights and darks.

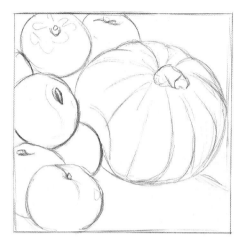

1 Remove the Grid Lines From Your Drawing

Once you've drawn all the shapes accu-rately, gently remove the grid from your drawing with the kneaded eraser. This should be easy to do if you drew your lines lightly. If you struggle to remove the lines, you drew them too dark and you should redo the line drawing. Once the grid is removed, you should have a group of spheres like this. You are now ready to begin rendering the tones.

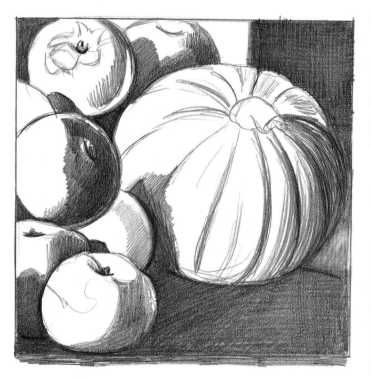

2 Establish the Darkest Darks

Always start with the darkest darks, just like you did with the sphere. This creates the light source and helps to create the shapes. Remember that cast shadows are the darkest because they are directly blocking the light.

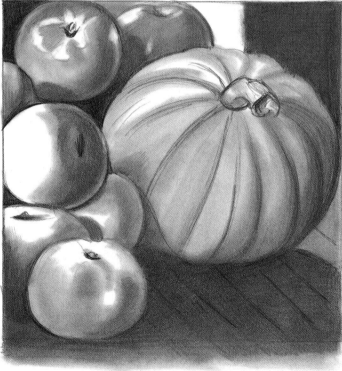

3 Create the Halftones

Use a tortillion to blend the tones to create halftones and smoothness. You may have to reapply the lines indicating the indentations in the pumpkin.

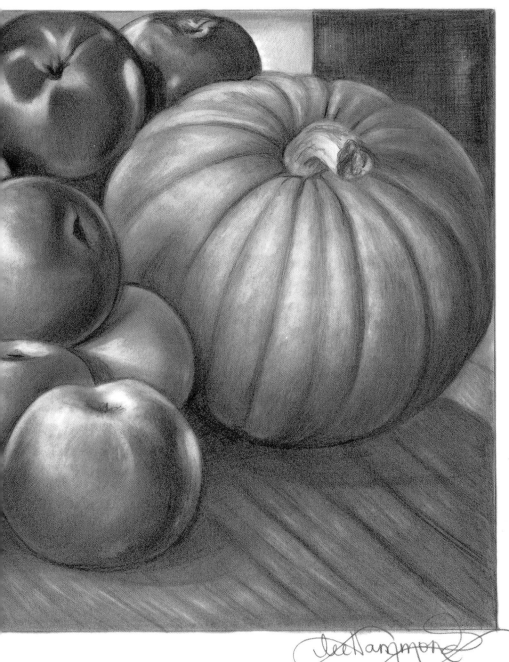

4 Build and Blend the Darks, Then Lift the Lights to Finish

To finish the drawing, keep building up the intensity of the tones. Continue adding darks until they are as black as possible in the darkest areas. Remember to blend your tones after each layer.

Create a point on your kneaded eraser and lift the subtle nuances of reflected light and highlights from all the raised areas of the pumpkin, along the edges of the apples, and in the wood grain of the table. This gentle lifting is the final stage to your drawing. Do not dab with the kneaded eraser when lifting light. You cannot create definite shapes with the eraser unless you control it like a pencil.

Lee's lessons

Light always looks more realistic when it is lifted out of the drawing rather than being drawn around or left out.

Practice Drawing Rounded Objects

Now that you've completed a few step-by-step demonstrations, try some drawings on your own using your acetate grid. These illustrations combine many of the drawing elements we reviewed on the previous pages. The overall shape is still the sphere. Follow the shapes of light and shadow to re-create the tomatoes and the teapot. Have fun!

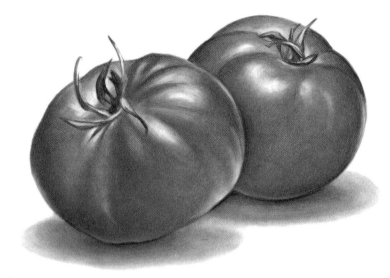

Graph and Draw the Tomatoes
These tomatoes are basic spheres. A hard edge is created where they overlap and highlight areas exist over their indentations.

Graph and Draw the Teapot
Sometimes objects have protruding elements, such as this teapot. The overall shape is clearly that of a sphere, but the handle, top and spout add new dimensions. Study these areas closely. Find the reflected light and shadow edges that indicate the light source.

Ellipses

So what happens when round objects no longer look perfectly round? If you look at a cylinder, you know that if you viewed it from the top it would look like a circle. But, when viewed from the side, you see a circle in perspective. This perspective represents distance and changes a circle into an ellipse.

Look at the wagon wheels. If they were still on the wagon they would look like perfect circles. But these wheels are lying on their side, so we see the wheels in perspective. Receding lines are made shorter than they are in reality to create the illusion of depth. This is a phenomenon called *foreshortening*. It is what turns a circle into an ellipse.

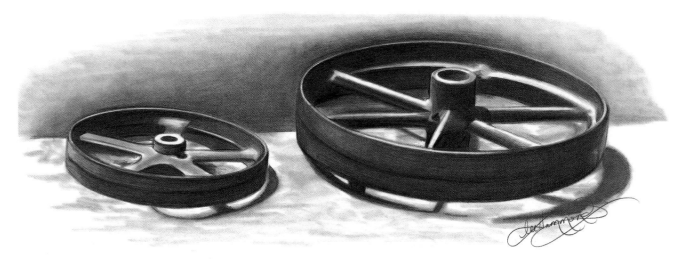

Perspective Creates Ellipses
Circles viewed from the side, such as these wagon wheels, are not perfect circles. Seen in perspective, they look slightly stretched out. The degree of the ellipse changes as your perspective changes.

Horizontal Ellipse
This is a circle viewed from above. Instead of a thick appearance, like the vertical ellipse, this ellipse seems flattened out.

Standard Circle
This is a circle viewed straight on.

Vertical Ellipse
When viewed from a different angle, perhaps closer to a side view, the shape appears thinner than the full circle. This is called an ellipse, which by definition is a circle in perspective.

Everyday Cylinders

Cans, lampshades, bottles and jars are just a few examples of everyday cylinders that contain ellipses. Like the wagon wheels, they all have circular tops that change into ellipses when viewed from from the side. The degree of the ellipse changes as vantage points change.

Chances are you'll find ellipses and cylinders to draw all over your house. Just remember the Equal Quarters Rule as you draw (see Lee's Lessons, page 41). Keep altering your edges a little at a time when drawing until your ellipses appear correct. Just as the basic shape of the circle changes to become a tomato, the basic shapes of the cylinders and their ellipses alter to become objects such as these.

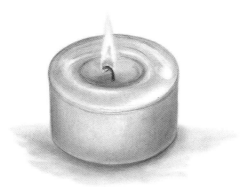

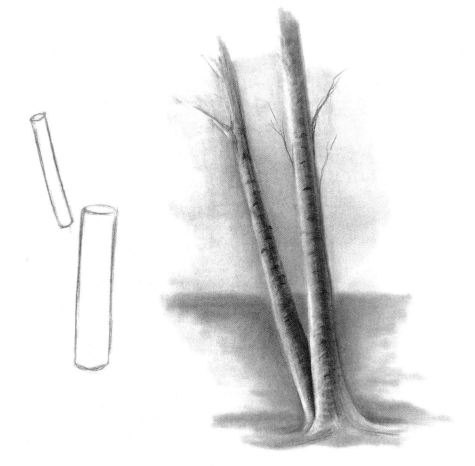

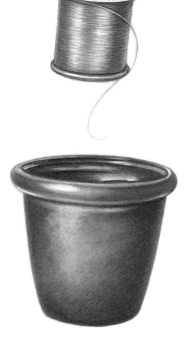

Textured Cylinders
The trunk, limbs and branches of a tree are nothing more than textured cylinders. The five elements of shading make evident the roundness of the objects.

Draw Everyday Objects Using Cylinder Basics
The pot and the spool are similar in their angle and view. But the candle is seen from a higher perspective, so we see more of its top. It appears to be rounder than the pot and the spool, but it isn't. The ellipse just changes depending on our point of view.

Practice Drawing Through

There is a mathematical way to produce an ellipse based on the degree of pitch and the angles. But you don't need a formula to tell you when an ellipse is off. When an ellipse is drawn incorrectly, your brain screams that something is wrong. Here are three tips to drawing correct ellipses:

- Remember, you are drawing a circular shape; there should be no flat spots or pointy areas in the smallest area where the ellipse curves.
- Visualize all sides of the elliptical object and draw the complete ellipse before shading. Try to to see through it.
- Remember, you should be able to fold your ellipse in half, with all sides matching.

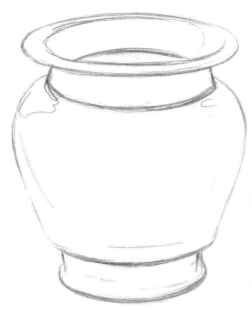

Start With an Accurate Line Drawing
When drawing any object, having accuracy in form in the beginning is essential. It allows you the freedom of blending and shading without having to make structural changes. Altering shape is very difficult after the tones have been added.

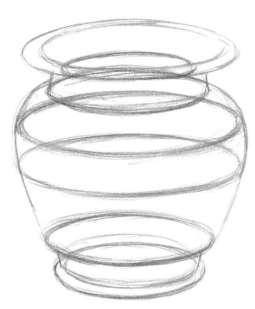

Visualize All Sides of Elliptical Objects
The ellipses encompass the surface of the pot, all the way around. Drawing through the object to complete the ellipses helped the pot look symmetrical and realistic.

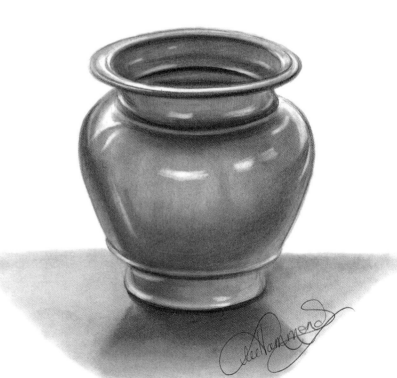

How Did Seeing Through the Object Help?
By visualizing the ellipses within this pot, and creating the basic shape accurately in line form, the blending can then create the illusion of the pot's surface and take the drawing to completion.

Draw a Tree Trunk

Tree trunks and limbs are made up of cylindrical shapes. However, different trees have different textures, and that can make them a bit of a challenge. The dark color and roughly textured bark of the elm tree, for example, causes light to reflect off its surface in an irregular fashion. Follow this step-by-step demonstration to learn how to capture the texture while staying true to the tree's basic shape. We'll talk more about trees and textures in upcoming chapters.

In the meantime, think of other things that are tubular in shape that could be used for drawing practice. Poles, garden hoses, snakes: All have the same basic characteristics.

Elm Tree Bark
This tree trunk is extremely textured, which alters the way light and shadows appear.

1 Begin the Foundation

Start with light shading as a foundation. This begins the process of creating shape and form, much like drawing an ordinary cylinder.

2 Build the Texture

Add irregular pencil lines to represent texture. The dark lines represent indentations and recessed areas of the tree bark, making it appear rough.

3 Deepen the Tones and Lift the Light

Deepen the tones on the shadow side to maintain the cylindrical shape and help define the light source. Increase the darkness of the texture within the shadows.

Lift the light out on the highlight side with the kneaded eraser. Not only does this create more texture, but it keeps the light source strong. The end result is a strong sense of texture without losing the illusion of the cylindrical shape.

Draw a Watering Can

Just like the teapot was a sphere with protruding elements, this watering can challenges you to draw a cylinder with protruding elements.

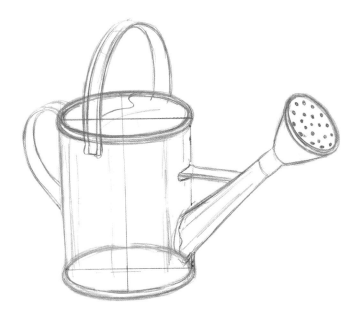

1 Create the Line Drawing

Make sure your ellipses are accurate and evenly shaped. Divide the ellipses into four equal parts to make them even. Be sure the tightest curves are not pointed. Use a ruler to get the edges of your cylinder sides straight.

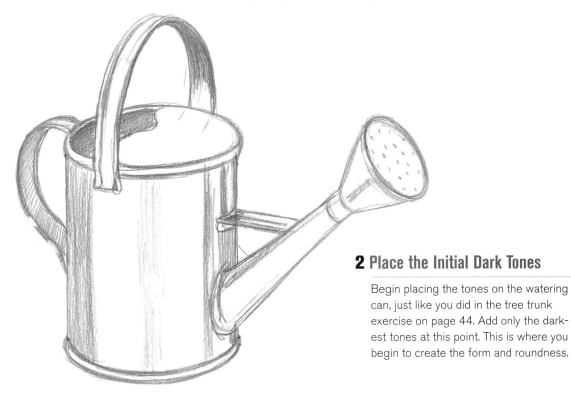

2 Place the Initial Dark Tones

Begin placing the tones on the watering can, just like you did in the tree trunk exercise on page 44. Add only the darkest tones at this point. This is where you begin to create the form and roundness.

3 Fill In the Remaining Tones

Continue adding tones to the top of the can, the handles and the spout. Make sure you evenly place your pencil strokes for smooth blending.

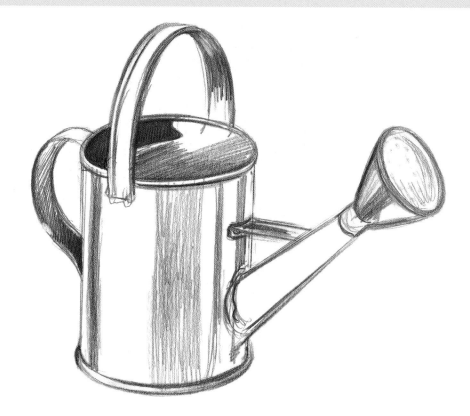

4 Blend the Tones Into the Whites

For a smooth look, use a tortillion to gently blend the tones into the light areas. Leave the lightest areas bright for a reflective, metallic look. Add the holes into the watering spout.

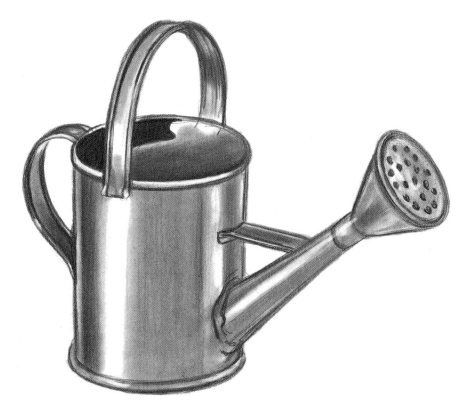

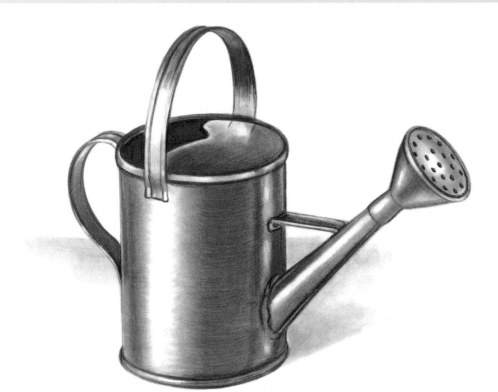

5 Finish the Drawing

To finish the drawing, lift the light areas to intensify the shine of the metal. Continue to darken and blend the dark areas until you are satisfied with the tones.

things to remember

- A sphere or cylinder can be changed into many different objects, just by changing the way you apply the tones.

- Combine repeated spheres and cylinders for more complex shapes.

- Look for the five elements of shading when drawing rounded and spherical objects, particularly reflected light.

- Foreshortening is when the shape of an object appears distorted because of the angle in which it is being viewed.

- An ellipse is a circle in perspective.

- Your eyes will tell you when an ellipse is not symmetrical.

- An ellipse can always be divided into four equal parts. You should be able to fold it in half either direction with all parts matching.

- The edges of an ellipse should always be curved with no flat areas. The ends of an ellipse, at the tightest curves, should never appear pointed.

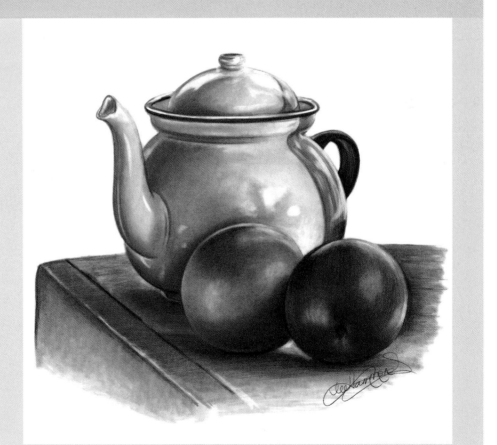

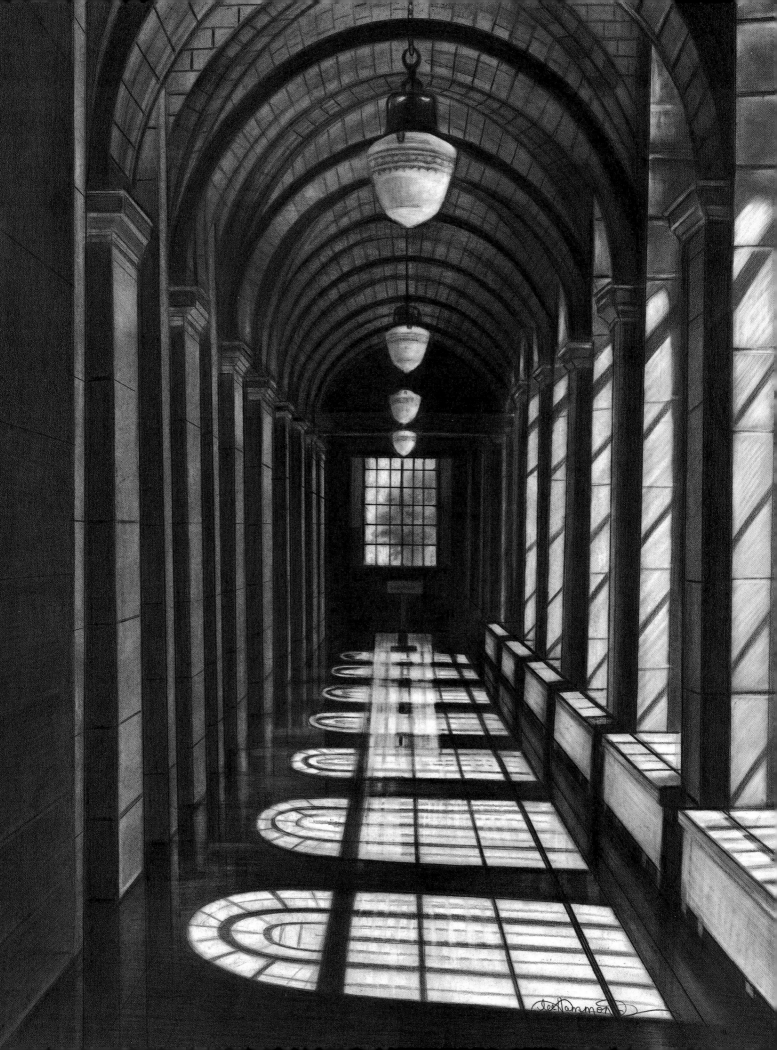

Rectangular Objects & Perspective

Now that you've learned how to capture gentle curves and roundness in your artwork, it is time to switch gears and capture the flat and square things in life. We are surrounded by objects that have flat sides. Tables, chairs, televisions and houses all have the cube as their basic shape.

This hallway is filled with rectangular objects, but it is also a great introduction to one-point perspective where all lines appear to converge at one point of origin—in this case—at the window. Use a ruler to follow the lines to this point. In this chapter you'll learn to recognize rectangular shapes in everyday objects and how to make them look real using simple methods, like making sure all of your vertical lines are parallel to the paper's edge.

chapter four

Illuminated Hallway
Graphite on two-ply bristol paper
17" × 14" (43cm × 36cm)

Perspective Basics

Entire books have been written about perspective. Basically, images change depending on the vantage point from which you view them. Areas that are closer seem much larger, while areas farther away seem to shrink. In realistic drawing, you must always remember this. Your artwork reflects where you are in relation to your subject matter.

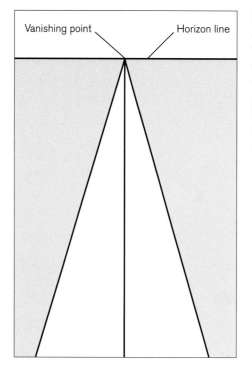

Vanishing point Horizon line

One-Point Perspective Simplified

A train track or road is large up front and converges into a point in the distance. This represents *one-point perspective*, when everything converges at one point out on the horizon. That point is called the *vanishing point*. The vanishing point rests on the *horizon line*. This horizon line represents your own eye level when looking straight ahead.

Two-Point Perspective

Each side of this house recedes back to two separate vanishing points. You can see where I have drawn the horizon line and followed the edges of the house to their vanishing points. It's important at the very beginning to make sure that all the vertical lines are perfectly vertical and parallel to the edges of the paper.

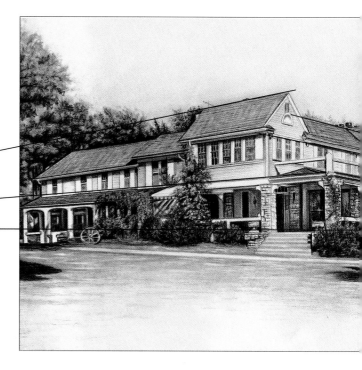

Two-Point Perspective Above Eye Level

The entire cube is above the horizon line, which means you are viewing it from a lower vantage point. You have to look up at the cube. If this was a building, you would be at the bottom of a slight hill, looking up the street. The light is coming from the left, making the side on the right appear darker.

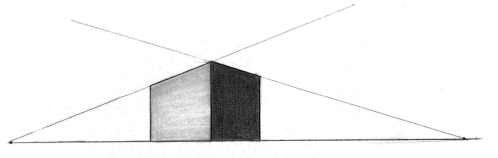

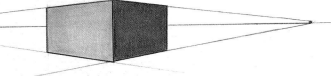

Two-Point Perspective at Eye Level

In this example the cube horizon line falls right in the middle of the horizon line. You are viewing the cube straight on and are standing on the same level as it is.

Above the Horizon Line or Worm's-Eye View

This cube is elevated, floating above the horizon line. It is much higher than eye level and you see its bottom. Can you see how the lines converge at the horizon line at the same points?

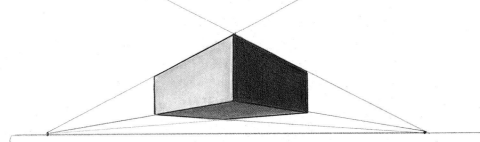

Below the Horizon Line or Bird's-Eye View

This time we are much higher than the cube and the horizon line, looking down on it.

Everyday Rectangular Objects

You learned the main difference between drawing rectangular objects and rounded ones in chapter two. Whereas gradual value transitions exist on rounded objects, more abrupt transitions can be seen on rectangular ones. Each surface on a rectangular object will have a different tone.

Rectangular objects are made up of flat surfaces that come together, creating hard edges. As you learned before, each time you have a hard edge, reflected light is created. Everything with an edge, lip or rim will have reflected light along it.

Once you begin to look, you'll see cubes everywhere. From stairways to furniture, you'll find the cube shape in all sorts of things. Even though a stuffed chair is soft and curved, the underlying shape is very angular and geometrical. Practice drawing rectangular objects in perspective. Soon, it will become second nature to you!

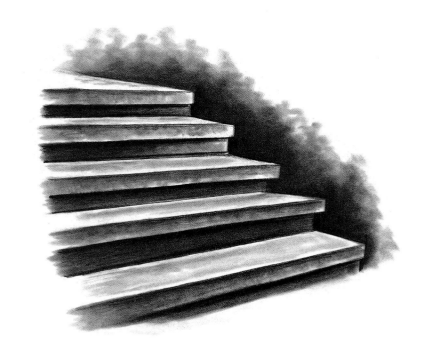

Draw Stairs as Cubes

Each step has three surfaces: the top, the overlapping front edge and the recessed front. The steps appear to get smaller as they recede, so the step at the top should be smaller than the one at the bottom. Like all perspective drawings, make sure that all the vertical lines are parallel to the paper's edge.

The top of each stair is illuminated by the sun. The overlapping front edge casts a shadow on the recessed area. Look for reflected light along each edge when applying your shading. When you drew the pearls in chapter three, you thought of each piece as a separate sphere. Here, think of each stair as a separate cube.

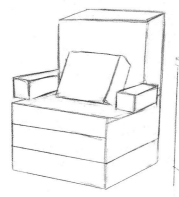

Find the Basic Shapes

Look for the underlying basic shape in everything you draw. The chair, the chair cushion, the pillow and the chest of drawers are all cube shapes. In catching the shape you also get a feel for the perspective lines. Notice how the portion of the chest of drawers nearest to us is larger than the portion closest to the chair. When you move to the rendering stage, you can just follow your initial lines. In the finished drawing, the drawers follow the same perspective rules.

Draw a House in Perspective

A house obviously has the cube as its basic shape, but the perspective is not always so obvious. An architect will begin working on the angles and perspective lines right away. But as artists, we draw what we see first, then use the rules of perspective to correct the drawing.

To correct the initial sketch, I located the horizon line and followed the lines of the structure with a ruler to where they converged at that line. You can see the horizon line drawn on both sides of the drawing. The dot represents one vanishing point. All the angles on the front of the house go to that point. All the angles on the side of the house go to a point off of the page on the left side.

1 Create the Grid and Line Drawing

Lightly place the same number of squares on your drawing paper and draw the shapes you see in each square.

Use a ruler to note the horizon line and the vanishing point on the right side. The horizontal lines on the front of the house should lead to that vanishing point. Take your lines to that point with your ruler. Keep your vertical lines parallel to the sides of your paper.

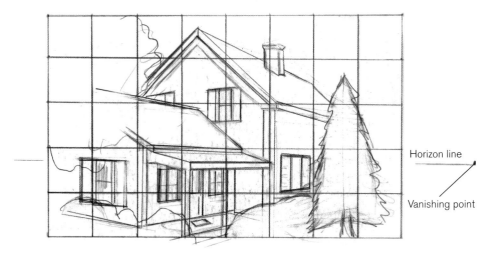

Horizon line

Vanishing point

2 Remove the Grid and Place the Darks

Gently remove the grid lines. Begin placing the dark tones in the drawing. At this point, the drawing is beginning to look realistic.

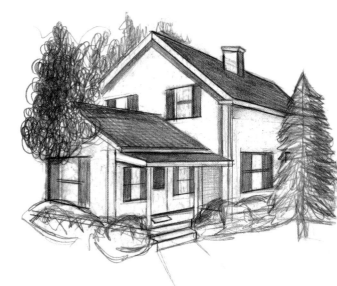

Horizon line

Vanishing point

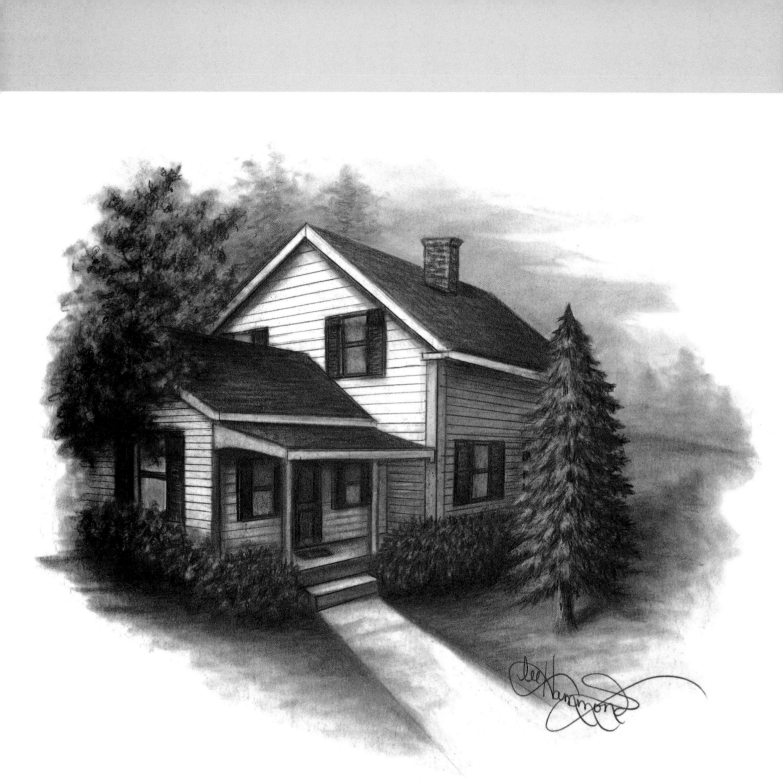

3 Finish the Drawing

The deeper the tones, the lighter the highlight areas appear. The light source comes from the left; so add tone to the front of the house and add a cast shadow behind the pine tree to make it more obvious. Use the foliage of the trees to accentuate the light edges of the house. Lighter trees behind the house and in the background create the illusion of distance (see page 106).

To create the siding, pivot your ruler down from the vanishing points and draw evenly spaced lines. Use the horizon line and vanishing points for all edges to keep them consistent with the perspective.

Use your tortillion to blend the tones in the siding, windows, grass and trees. Be careful not to blend away the siding!

Draw a Room

When drawing rooms such as this, it is important to keep in mind the rules of perspective. This is an example of multiple-point perspective.

Because the components of the room are situated at several different angles, their lines converge at several different vanishing points. The two walls angle differently and come together at a "V" in the corner. The edges of each windowsill go in different directions off of the paper and end up at a horizon line out in the distance. The furniture has a different angle. The lines of the couch and the edges of both coffee tables in front of it are parallel to each other. The edge of the end table is parallel to the side of the couch.

It is extremely important to use a ruler to make these lines crisp and clean before you begin shading. If the lines are not drawn properly, no amount of shading will correct them.

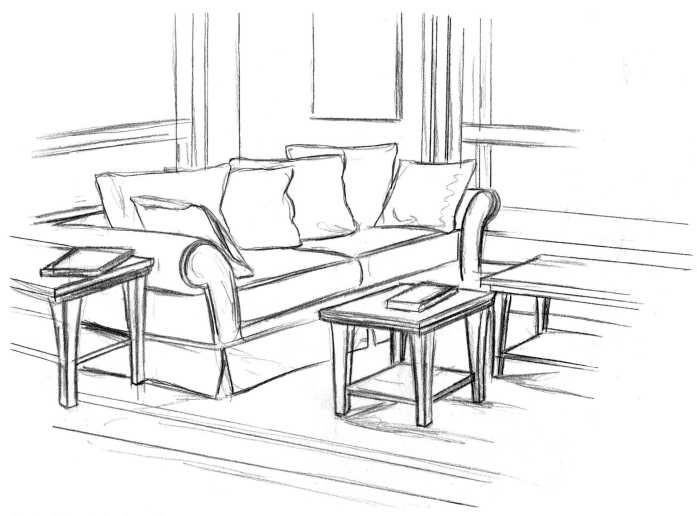

1 Create the Line Drawing

Always use a ruler when drawing a room such as this. Look for parallel lines and edges, and remember the converging properties of perspective.

Be sure that the angles are right and that objects appear to get smaller as they recede. If the drawing looks off, it probably is. Make all your vertical lines perfectly straight and parallel with the edges of your paper.

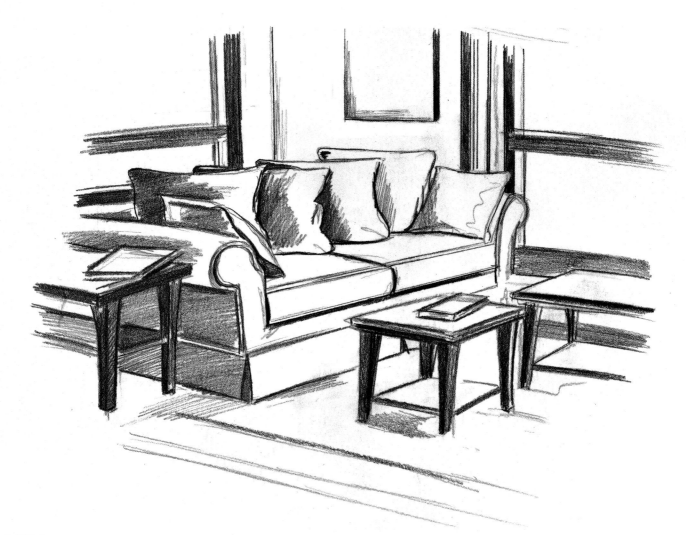

2 Fill In the Darks

Look for the areas of light and shadow. Apply tones to the darker areas of the drawing to start creating shape and form. At this stage the light source becomes very obvious, coming through the window on the right.

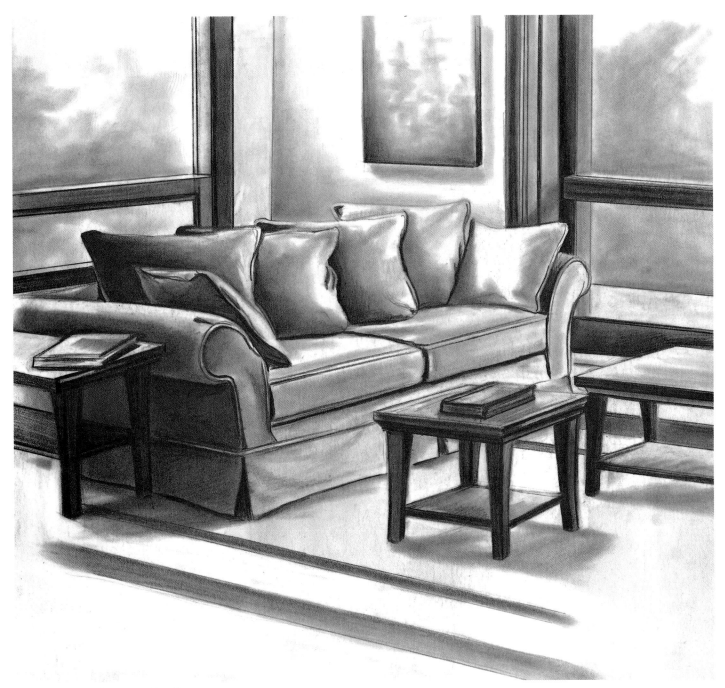

3 Blend and Deepen the Tones

Blending creates the realism of your drawing. Continue to deepen the dark areas to further enhance the illusion of sunlight. To create the appearance of distance, blur the scenery seen through the windows with a dirty tortillion. Look for cast shadows under the tables, next to the couch and below the picture on the wall. Lift the highlights with a kneaded eraser.

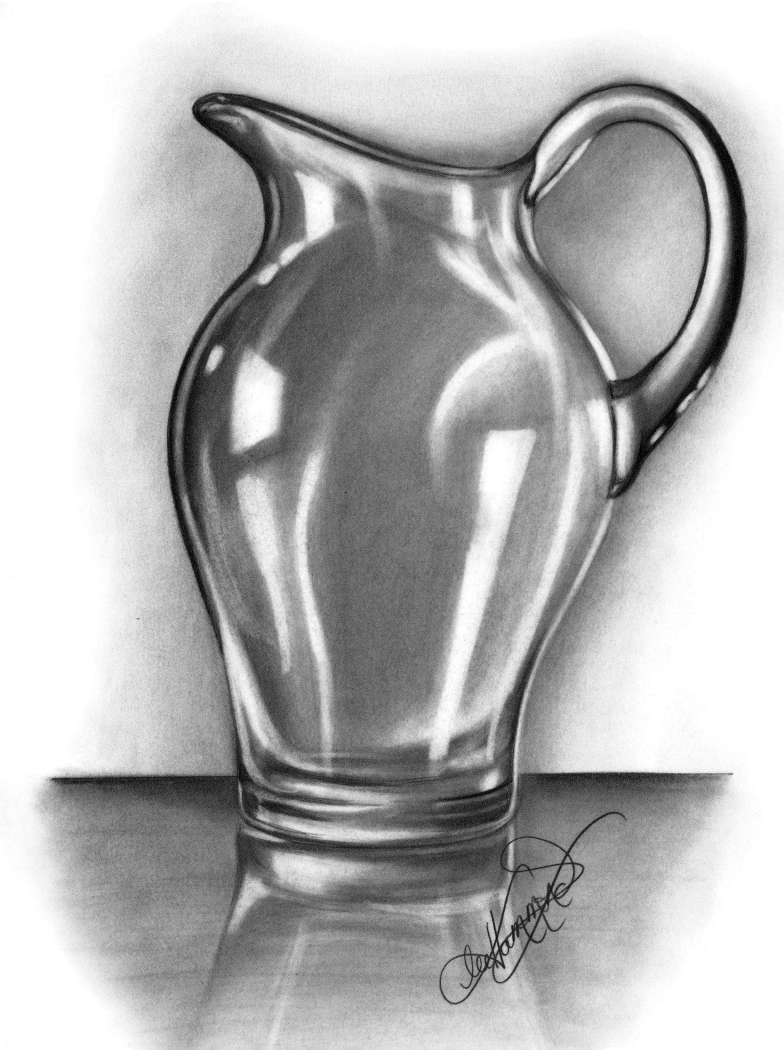

Transparent Objects

"How in the world do you draw something that is transparent?" As an art instructor, I hear this question over and over again. I just smile. It really isn't that hard if you look at the object as shape and patterns. The puzzle piece theory that we covered earlier unravels this mystery of drawing.

Clear glass is very reflective. When you draw transparent things, you render everything that reflects off of them rather than the actual objects. That's why lakes in paintings generally appear blue. They reflect the blue of the sky.

Study this drawing of a clear glass pitcher. Squint your eyes to see it more abstractly. It is really a basic shape filled with light and dark patterns. All transparent objects are filled with light and dark patterns. Conveying these patterns is the key to rendering realistic transparent objects.

chapter five

Glass Pitcher
Graphite on two-ply bristol paper
14" × 11" (36cm × 28cm)

Draw a Glass Vase

I told you in the introduction that drawing glass is not as hard as you might think. Now here's the proof. Even though glass is clear, it is reflective and takes on the tones of its surroundings. Follow this demonstration to see how easy it can be.

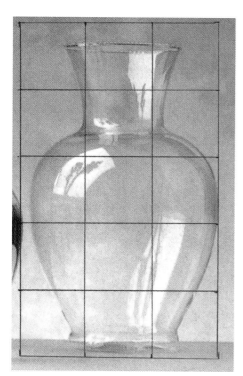

Reference Photo

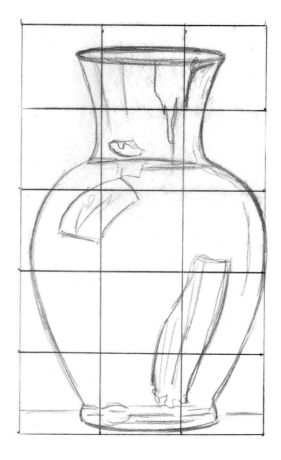

1 Transfer the Drawing

Lightly draw 15 boxes on your drawing paper. Draw the shapes you see in each box. Keep the sides of the vase as symmetrical as possible.

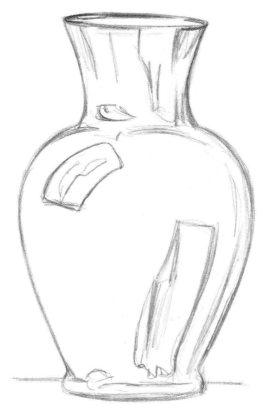

2 Remove the Grid

Gently remove your grid lines with the kneaded eraser.

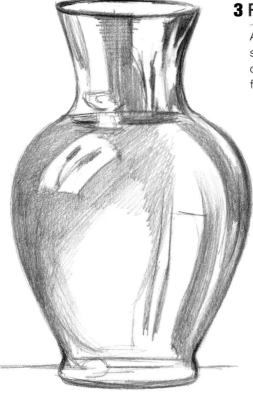

3 Place the Darks

Apply light tones in the darkest areas you see in the reference photo. This begins to create the roundness of the vase's surface.

4 Darken and Blend to Finish

Darken the outside edges. Blend the rest of the tones with a tortillion until they are very smooth and gradual. Leave the highlight areas. These have very distinct shapes where the light is reflecting.

Place a little shading below the vase to give the illusion of a tabletop.

Vase With a Flower Arrangement

Notice how the tones change when you add the flowers to the vase. Because of the darkness of the flowers, the tones of the vase deepen and become more intense. Also, the water inside adds a waterline. Use your acetate grid to graph and draw this example.

Glass Pitcher and Eggs

You've learned how to draw a plain glass container with the glass vase. Did you try creating the vase with the flower and water? If you had trouble with that, follow this demonstration, then try it again. Adding liquid to glass only changes the patterns and values you see; nothing else changes about your drawing.

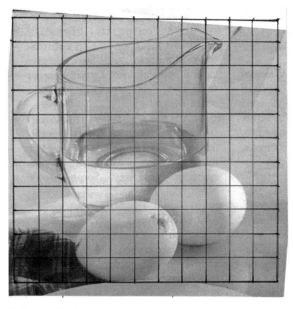

Reference Photo

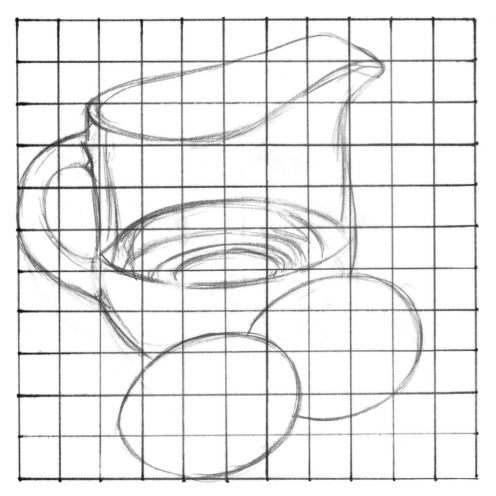

1 Transfer the Drawing

Lightly draw the grid on your paper. Then draw what you see in each box.

2 Apply the Darkest Tones First

Erase your grid lines and begin to fill in the dark tones. This drawing has very light values, so the darkest tones are few. Refer to the five-box value scale on page 18 for tone comparisons.

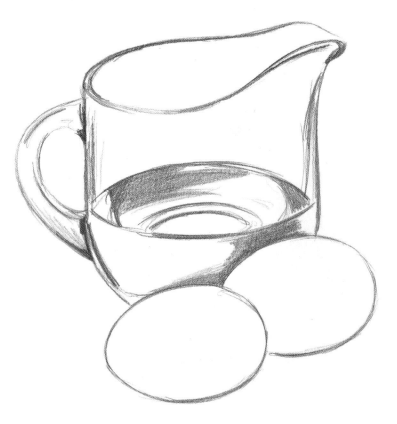

3 Create the Halftones

Use your tortillion to gently blend to create halftones. Refer to the graphed reference photo to compare the lights and darks.

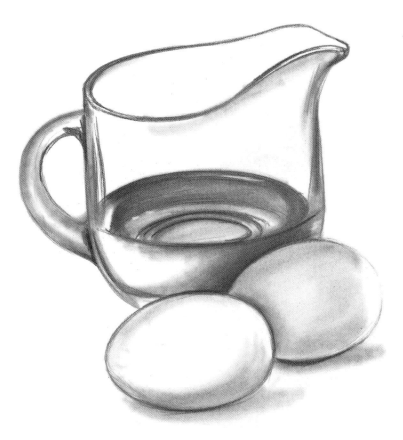

4 Blend the Tones, Lift the Highlights and Check the Darks to Finish

Blend the tones throughout. Create a point on your kneaded eraser and lift the highlights out of the glass and liquid. Draw the highlights out with the eraser; do not dab. Drawing the highlights out gives you greater control and realism. Check your darks once more and you're finished!

Patterns in Glass

Look at the multitude of patterns created in these glass items. The highly reflective surfaces gather images of everything around them, along with the light source.

Think of all the glass patterns you see as puzzle piece exercises. All of these drawings are basic shapes filled with small patterns of lights and darks. It really simplifies things. Find some magazine pictures of other glass items and practice drawing them using the grid method.

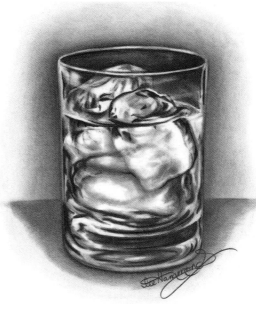

Look for Patterns in Ice

Ice is nothing more than small patterns of light and dark shapes. Placing some shading in the background will help define the light rim of the glass.

Glass With Ice
Graphite on smooth two-ply bristol paper
9" × 12" (23cm × 30cm)

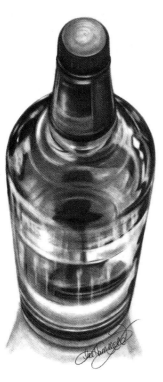

Apply Darks, Blend Halftones and Lift the Lights
The light and dark patterns in this bottle create its roundness and contours. To create light and dark patterns like these, apply the dark shapes first, blend the halftones, then lift the light. This system allows you to go back and forth as much as you like until you achieve the look you want.

Bottle
Graphite on layout bond paper
11" × 8 ½" (28cm × 22cm)

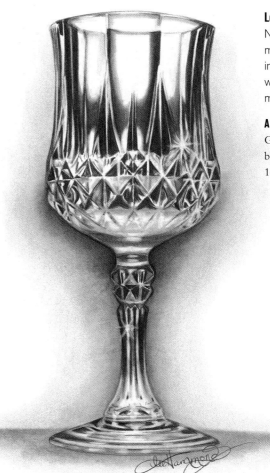

Look for Interlocking Shapes

Notice how the cut crystal segments the entire glass into many interlocking shapes. A grid drawing will make this complex subject much easier to draw.

A Crystal Glass
Graphite on smooth two-ply bristol paper
14" × 11" (36cm × 28cm)

Glass With Ice

This is an excellent example of how somewhat difficult subject matter is simplified when broken down into puzzle piece shapes. As you draw, pay particular attention to the ellipses that make up the rim, waterline and bottom of the glass.

1 Create the Cylindrical and Nonsense Shapes

The drinking glass is a cylinder. The ice cubes are patterns within that cylinder. Use a ruler to create the outside edges of the glass. Create the ellipses that form the rim, the waterline and the bottom. Be sure the arcs of the ellipses are rounded, not pointy.

Draw the nonsense shapes that make up the patterns of the ice cubes.

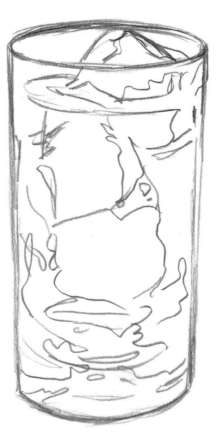

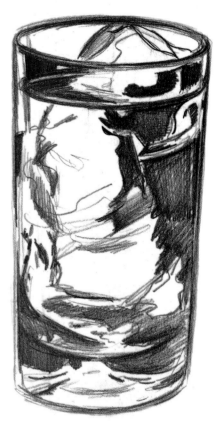

2 Fill In the Darks

Start filling in the dark patterns as shown. Forget this is ice and just draw shapes.

3 Deepen and Blend the Tones, Then Lift the Light

Continue filling in and deepening the tones within the patterns. Blend them with a tortillion. Lift out the light areas, particularly in the rim and waterline, with your kneaded eraser.

Create the illusion of water drops on the side of the glass and the puddle beneath it. Place your tones like mine to make it look wet and reflective.

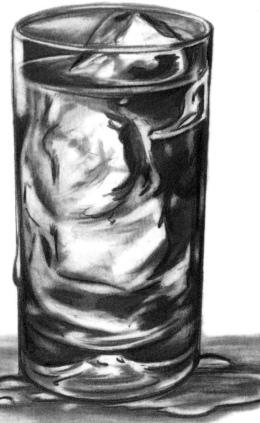

Not All Glass Is Transparent

As you've read already, glass is unique as a drawing subject not because it is necessarily transparent but because it is so reflective. Not all glass is transparent. What happens then? What do you do when the glass is opaquely colored or filled with something that changes the color?

Glass, regardless of color, is very reflective with many highlights. Glass that has a strong, deep color contains highlights that stand out more. The contrasts between light and dark appear more intense. Making the highlights seem more defined often makes things easier to draw.

Because of the reflective nature of glass, when it is filled with something that changes the color, all the values are affected. A clear bottle filled with dark liquid will have darker tones and greater contrasts between the tones and the highlights.

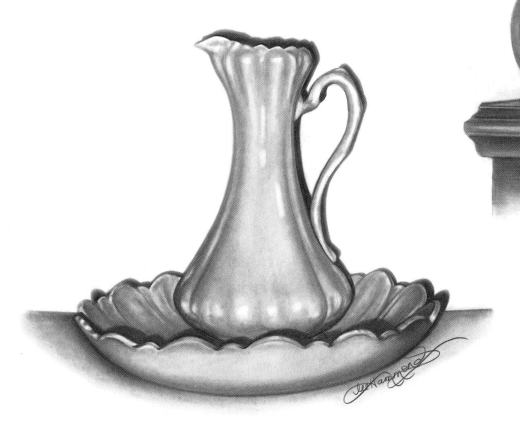

Create Highlights in Colored Glass
Compare the wine jug to the glass objects earlier in the chapter. The main difference is in the color. The true color of this jug is dark green. However, it is still glass and very reflective. You just need darker tones for the overall impression. Use the same blending techniques we've discussed. Capture the basic shapes, blend the tones, then use the kneaded eraser to lift out the highlight areas. It is the very same process, just a lot more of it, because of the deep color.

Define Glass With Light and Shadows
The true color of this old-fashioned bowl and pitcher is off-white. White and light subjects generally have more halftones and grays than extreme darks and lights. But the highly reflective surface of the glass and the irregularities of its shape cause the light to create many light and dark patterns. The overlapping objects create hard edges and shadows, which create more reflected light around the edges.

Reflective Windows
Remember the reflectiveness of glass when drawing windows. Because of this reflective nature, you will often see objects reflected in the glass rather than what's on the other side of the window.

Detail
In this close-up of one of the window panes, you can see the shading and detail of the trees. The glassy surface of the window is reflecting the surroundings of the trees outdoors. You don't need a lot of detail to make your windows mirror their surroundings. Just keep your shading and perspective angles consistent.

Draw an Ink Bottle

This drawing combines most of the lessons you've learned so far. You'll practice perspective as you create this bottle sitting at an angle. And you'll hone your skills creating rectangular objects while you practice creating the gently curved edges and sphere-like shapes of the bottle's sides and top.

The dark color of the liquid within the bottle causes dark tones to reflect around the surface, creating many light and dark patterns. These patterns represent the liquid inside as well as the surroundings reflecting on the bottle's surface.

1 Create the Line Drawing

Begin with an accurate line drawing. Use a graph over this one to help achieve your shapes. The angle of the bottle makes it more difficult. Capture the shadows and highlight areas as shapes.

2 Add the Tones

Add the tones to the patterns of shapes. Leave light areas for the edges, the fluid line and highlight areas.

3 Blend, Deepen and Lift the Tones

Blend the tones with a tortillion and deepen them if necessary. Be sure to blend after each application. Use the kneaded eraser to lift out reflections to make the glass look shiny.

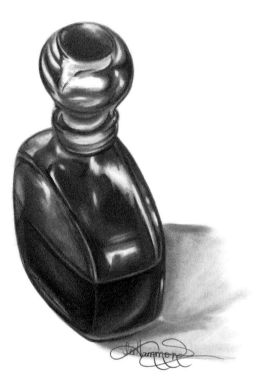

4 Finish the Drawing

Continue adding and blending tone until it is very dark. Go over the highlights and reflections with a kneaded eraser. If this bottle had a light-colored liquid inside, the tones would appear lighter, but the patterns and highlights would be the same.

- Drawing clear glass is all about drawing patterns of lights and darks.
- Use the puzzle piece theory to simplify transparent objects.
- Most glassware is made up of ellipses and cylinders.
- Colored glass just requires more tone. It still is very reflective, with many highlights.
- You don't need a lot of detail to describe the reflectiveness of glass.

Hourglass
Graphite on two-ply bristol paper
14" × 11" (36cm × 28cm)

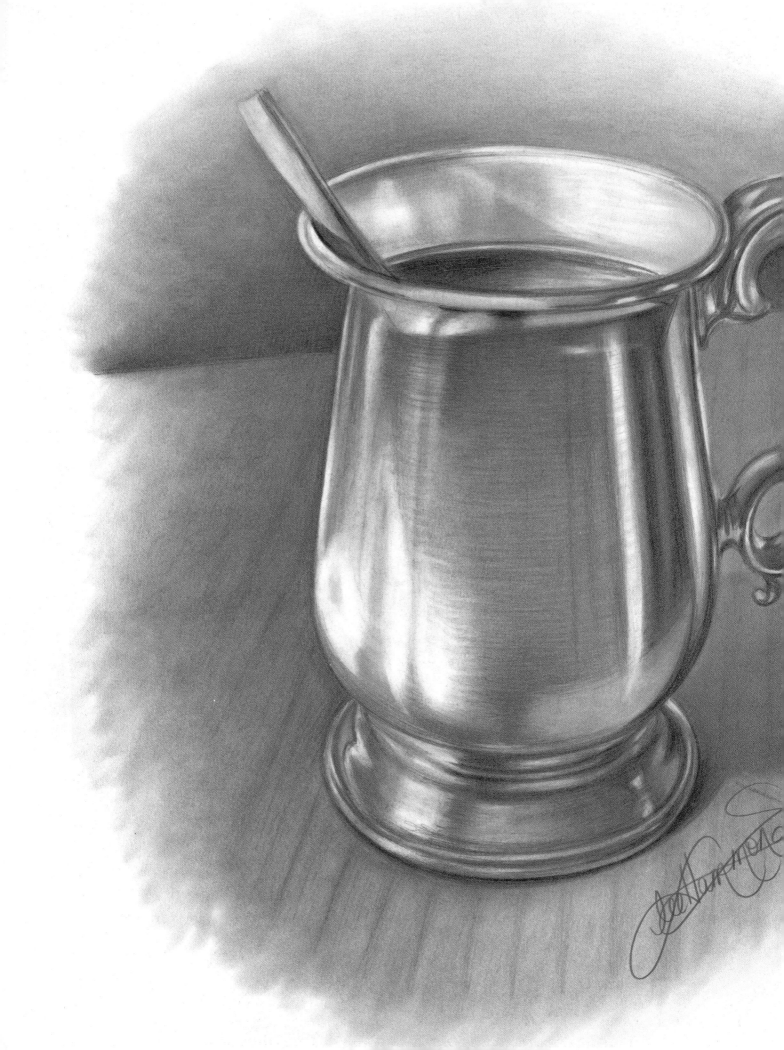

Metallic Surfaces

Drawing metallic surfaces is very similar to drawing glass because we are dealing with highly reflective material. However, your light and dark contrasts are much stronger with metal. You'll find many more areas of total black and complete white than with glass, which has more subtle shades of gray. Capturing these extreme contrasts in tone is the key to realistically drawing metallic objects.

Compare this pewter mug to the glass items from the previous chapter. Notice how the contrasts in tone are even more evident on this shiny metal. The darkest darks on the pewter are nearly black, juxtaposed with highlights that are nearly pure white. Once you get some practice making your tones this extreme, you'll be well on your way to drawing realistic metal.

chapter six

Pewter Mug
Graphite on smooth two-ply bristol paper
14" × 11" (36cm × 28cm)

Metallic Surfaces Require Deep Darks

To create the look of metal, your darkest tones must be black. That's why drawing metallic objects is a sure way to practice drawing dark. The tones must be black to create the right look. If they are too pale, the drawing will look monotone and won't be convincing.

Use what you've learned about the puzzle piece theory when drawing metallic objects; all of those reflections can be confusing unless you break down the larger image into parts. Concentrate on making the darkest tones black. That will make your lights shine, creating the mirror-like quality of metal.

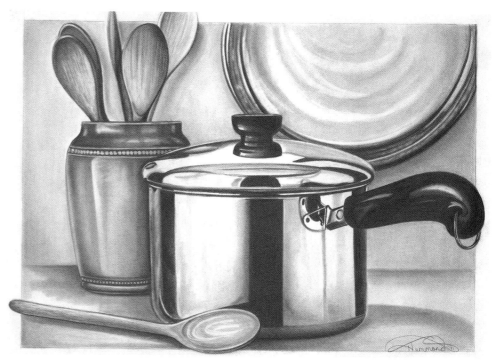

Draw Strong Contrasts for Chrome

The intense black of the chrome saucepan and lid makes the lights shine. That light reflects in both the pan and lid handles. Even the metal ring on the pan handle is a good example of how light and dark create a shape. You use the same basic methods to create metal as you did to create glass. The only difference is with metal, your darks must be black.

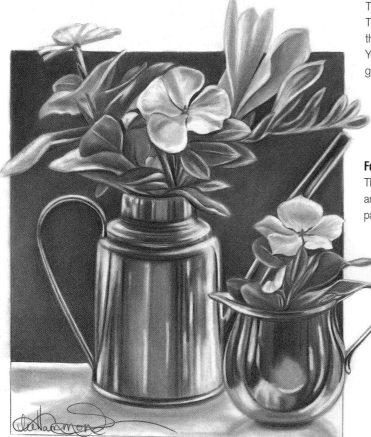

Follow the Patterns of Your Subject Matter

These silver containers have a lot of shine. The patterns on the watering can are straight because of the cylinder shape, while the creamer has curved patterns. Always follow the contours of your subject when creating patterns.

Lee's lessons

Create a border box for your drawings. Then allow your images to escape the border box like those on this page. Small things like this can make a big difference in the way your work is viewed. It's a fun way to make your drawing more interesting.

Draw a Pinball

Let's practice creating those darks with a simple sphere. This silver pinball shows how differently light reflects on a continuous metal surface. The intensity of contrast between black and white changes this from an ordinary sphere exercise into a study of extreme lights and darks.

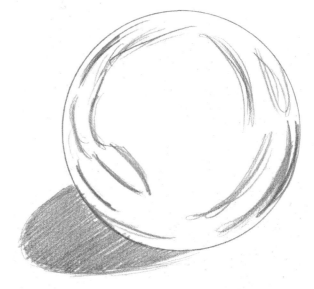

1 Create the Line Drawing

The beginning stage looks like a regular sphere exercise with a few extra patterns.

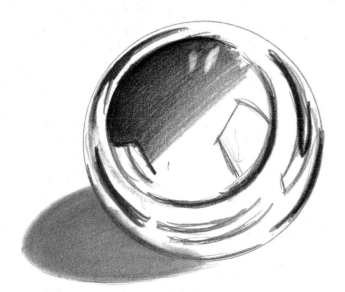

2 Define the Shapes and Add the Tones

Capture the irregular shapes created by the reflections. Make sure the reflected shapes follow the contours of the rounded surface. There can be no straight up-and-down lines. Start to fill in the dark areas.

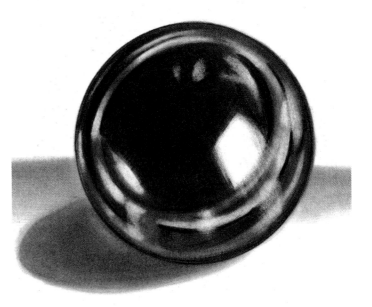

3 Fill In the Shapes, Blend and Lift the Lights

Drawing very dark, fill in the shapes. Blend your pencil marks and reapply the tones. Notice that in this instance the cast shadow is not the darkest dark; make sure your darks in the pinball are black. Leave the shiny areas bright white and use the kneaded eraser to create streaks of light.

Draw a Necklace

When metal is seen in long lengths, the lights and darks weave in and out. With a flexible, curvy object like a necklace, the lights will always be at the areas where the necklace bends and protrudes. These will be bright and the others dark because they are reflecting the surroundings. A necklace, especially if it is on a person, can only be lit on one surface.

As always with metal, it's the patterns of light and dark that make this necklace look shiny.

1 Create the Line Drawing

Everything begins with a simple line drawing. Draw the shapes you see.

2 Add the Darkest Darks

Add some shading to the part where the jewel attaches to the necklace; this is where your darkest darks will be. Fill in the darkest tones in the jewel. You will darken these even more in the next step.

3 Darken, Blend and Lift to Finish the Drawing

Darken the darks on the necklace to create the illusion of shine. Add shading to the lighter areas of the necklace and blend. Leave the highlight areas white for contrast. Add tone to the pendant and blend, then lift out some highlights to create a faceted look. Add a blended shadow behind the necklace for realism.

Draw a Pewter Teapot

All the illustrations in this chapter have intense areas of black and white with small areas of halftones. This silver teapot, because of its flat surfaces, captures light differently than a rounded object. Each flat surface or plane creates a hard edge that reflects light. When you drew the pinball, you had to make sure that your shapes followed the round shape of the sphere. Here, most of your shapes are vertical.

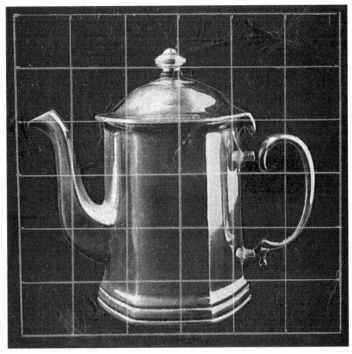

Reference Photo

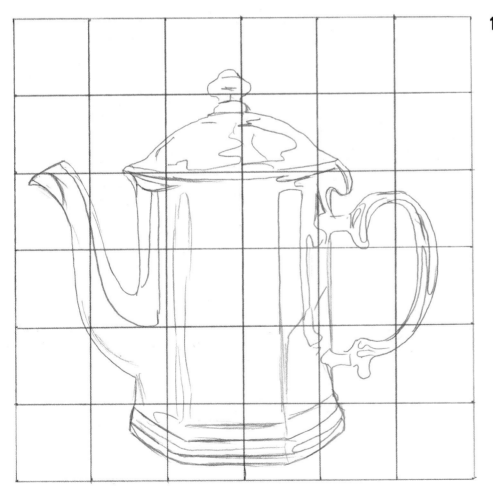

1 Create the Line Drawing

Remember to draw your grid lines very lightly so you can erase them later. Then concentrate on the shapes you see in each box. Forget about the teapot for now.

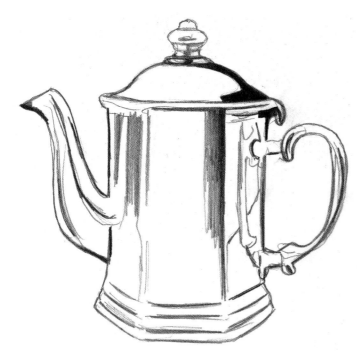

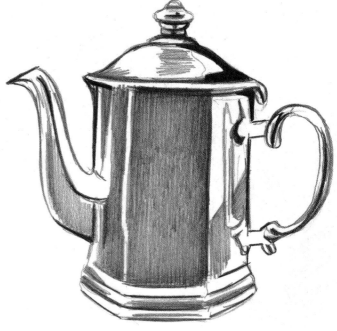

2 Erase the Grid Lines and Add the Tones

Carefully erase your grid lines. Begin adding in the darkest tones around the bottom of the pot, the lid and around the light edges. Leave areas of reflected light.

3 Fill In the Darks

Fill in the dark areas as smoothly as possible.

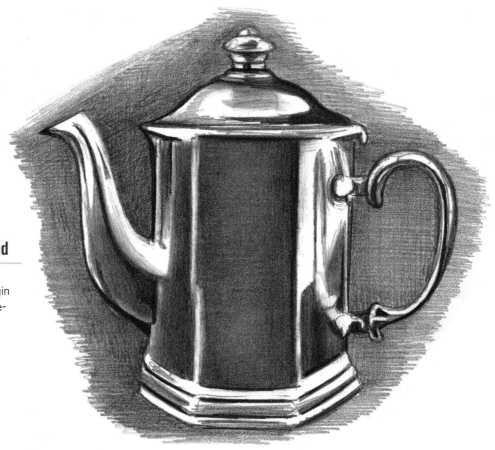

4 Add the Background and Blend

Add some background tone to help create the light edges of the pot. Begin blending the tones on the teapot carefully with a tortillion.

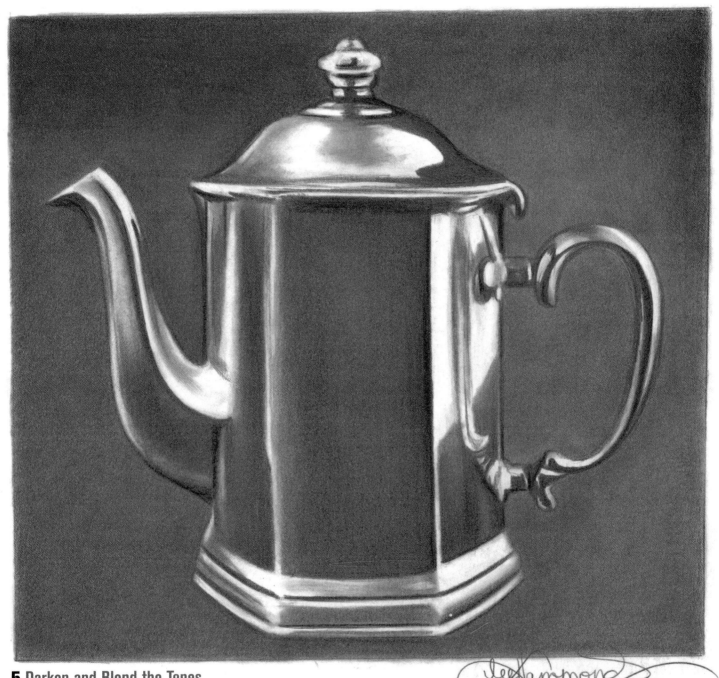

5 Darken and Blend the Tones

Continue to add tone to your darks until they're dark enough.
Be sure to leave the lights white. Deepen and smooth all of your
tones for intensity. Fill in and blend the background to an even
tone that is not quite as dark as the teapot itself.

Draw a Trombone

The trombone combines what you've learned about metal with what you've learned of ellipses and cylinders. Use a ruler to create the straight lines on the trombone and to help you visualize the ellipses. Remember to keep your patterns consistent with the form of the trombone.

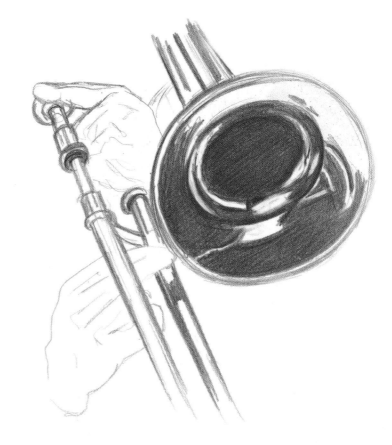

1 Create the Line Drawing

Graph this drawing or the finished drawing to capture the basic shapes. Use a ruler to keep the lines straight on the tubular shapes. The inside of the trombone will need to be very dark, so go ahead and fill in the darks there.

2 Fill In the Darks, Blend and Begin Shading the Hands

Darken the tones over all but the lights of the trombone. The inside is made up of extreme patterns of light and dark. Make the dark areas as black as possible. Blend your tones. Repeat this process until the darkest areas are virtually black.

Begin to define the lines in the hands. The areas where the fingers touch are hard edges and should be the darkest areas on the hands. Fill in the hands with light, even shading and blend. Leave the tops of the knuckles and the bright area around the ring. These will be the lightest areas on the hands.

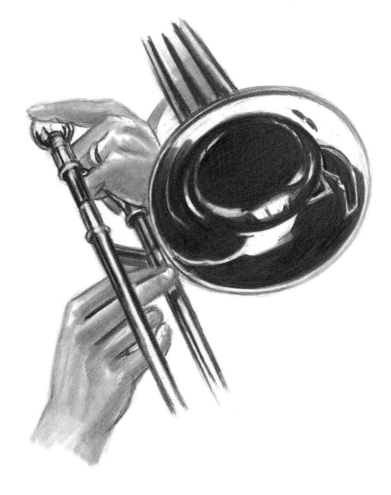

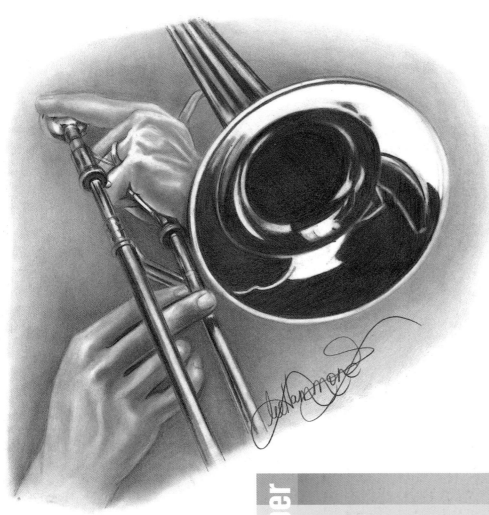

3 Refine the Tones and Add the Background

Go over the tones in your drawing. Use a tortillion to blend the tones thoroughly. Add darks to the areas between the fingers of the hand, around the fingernails and the ring. Form your kneaded eraser into a point to draw out highlights in the hand around the knuckles and places where bones or veins might protrude.

Create a nice, even, blended tone for the background to make the lights around the trombone really shine.

<div style="color:gray">

things to remember

</div>

- Contrasts in tone are the key elements to realistically drawing metallic objects.

- Metallic surfaces have extreme contrasts. Light and dark patterns are intense.

- Highly reflective surfaces can be complicated to draw, so use the puzzle piece theory to break them down.

- If dark tones are not deep enough, your drawing will appear pale and monotone.

- Always follow the contours of the object when drawing the reflective patterns.

Gazing Ball
Graphite on smooth two-ply
bristol paper
14" × 11" (36cm x 28cm)

Fabric & Other Textures

Clothing is a beautiful thing to draw and brings special challenges to artists because of the creases and folds. But fabric and folds can be seen in things other than clothing on people, so it is important to know how to capture them.

The creases, folds and textures like the ones in Raggedy Ann can be found all around you. The curtains on your window are a good example, as well as bedspreads, blankets, towels, tablecloths, upholstery and couch throws. In this chapter you'll learn to recognize and draw the various types of folds, as well as how to apply those folds to all sorts of subjects.

chapter seven

Raggedy Ann
Graphite on smooth two-ply bristol paper
14" × 11" (36cm × 28cm)

Draw Fabric With Five Basic Folds

There are five basic folds to look for when drawing fabric. Each fold has its own set of characteristics that makes it different from the others. Memorize the basic folds. When you can recognize and apply them, you'll demystify many drawing projects and your drawing abilities will jump tremendously!

Regardless of what type of fold you are drawing, include the five elements of shading. Watch for the areas of reflected light on all the creases and folds. If you look at each area, you will see the combinations of shadows and light that make folds resemble the cylinder exercises. Soft edges are found where the fabric gently bends. Hard edges are created where fabric overlaps.

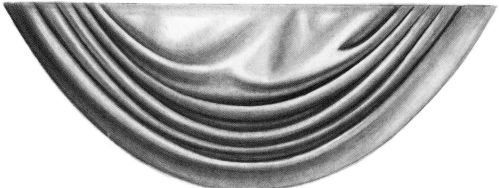

Drape Fold
The drape fold is created when fabric is suspended by two points. You will see this fold in cowl neck sweaters or when fabric is draped over something. The drape fold will make a "U" or a "V". Notice that the entire length of the U-shape has reflected light.

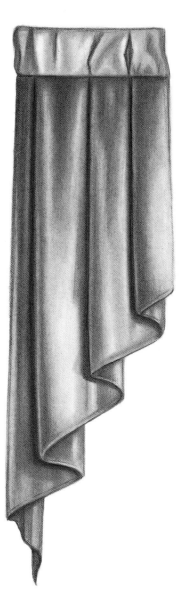

Puckered Fabric Creates Tubular Folds
This small detail from the Raggedy Ann doll shows how the puckered fabric around the collar creates tubular folds. When a tubular fold is created by being bunched, rather than hanging from a point of suspension, the tubular shapes can go in different directions than just hanging vertically.

Column or Tubular Fold
The column fold, also known as a tubular fold, is the most common of all the folds. You'll find it most often in drapery and clothing.

To recognize it, look for cylindrical folds that hang from one point of suspension. Approach it similarly to how you would approach drawing a cylinder. Review chapter three for practice.

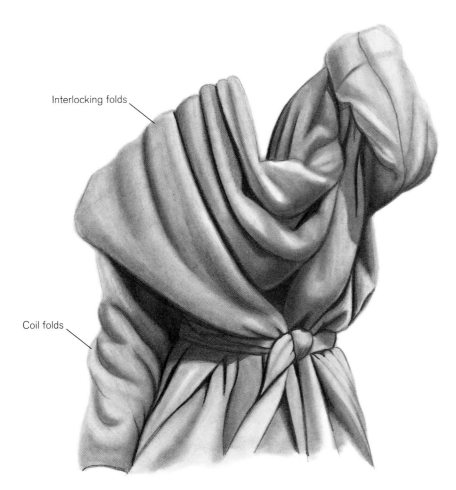

Interlocking folds

Coil folds

Interlocking and Coil Folds

When fabric falls in layers and the folds actually rest inside one another, interlocking folds are created. The loose fabric of this coat creates interlocking folds as it falls around the shoulder area. This could also be classified as a type of drape fold because the shoulders act as two points of suspension. Being flexible, fabric can hold many different types of folds at one time.

When fabric is fitted over a cylindrical or tubular shape, such as the sleeve of the coat, it creates a coil fold, named for its spiral appearance. A coil or spiral fold can also be found in a pant leg when the fabric bunches at the knee or a sock that has fallen down around the ankle.

Inert Folds

Inert folds are created when the fabric is not being suspended at all. The creases and folds can go in every direction. Because of the many layers, there will be a multitude of overlapping surfaces and hard edges.

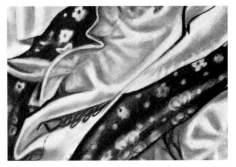

The close-up of the Raggedy Ann doll's apron is another example of an inert fold.

Practice Drawing Folds

Drawing a towel that is hung from one point of suspension will provide you with the practice you need for drawing column or tubular folds. The folds created resemble a cylinder. If you need to, review the cylinder information in chapter three.

Lee's lessons

You can gain extra practice by taking your own towel or other type of fabric and placing it in different positions to draw from. Study how the folds change according to how you hang it. This type of discovery and observation is the key to becoming a good artist.

1 Create the Line Drawing

Start with a light line drawing. Look for the tubular shapes—they resemble the cylinder.

2 Shade the Overlapping Areas

Begin applying dark tones where the fabric overlaps.

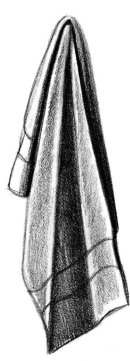

3 Fill In the Darks

Once you've established the darkest areas, begin filling them in, leaving the areas of reflected light. This is what makes these areas look curved.

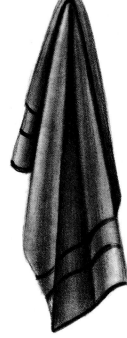

4 Blend and Lift to Finish

Use a clean tortillion to blend your tones. Then lift the lightest areas with a kneaded eraser.

Create Texture Using the Five Basic Folds

Many nonfabric textures can be created using the five basic folds we've already discussed. Objects or subjects may seem totally different and unrelated to one another, but you can draw them all with the same process of shapes, lights and darks. Everything has edges that reflect light and light areas that you can lift out with the kneaded eraser. The characteristics in a shell, for example, are virtually indistinguishable from folds seen in fabric.

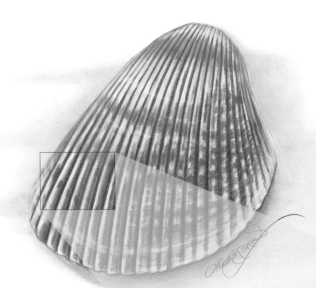

Column Folds in a Seashell

Each of the ridges on this shell has the traits of a column fold and requires all the same elements of shading to show form. The individual ridges of a shell are almost interchangeable with the column folds you might find in fabric.

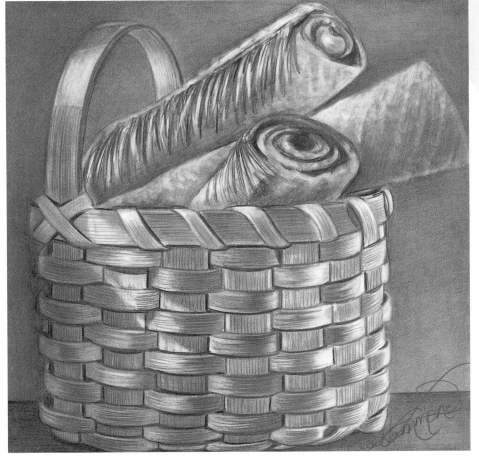

Interlocking Folds in a Basket

Basket weave can be a challenge because the strips are going over and under, and in and out of each other. They create extreme overlap situations. Look at each segment separately, and draw them one at a time. This keeps you from becoming overwhelmed by the "big picture" and helps you see it as a puzzle of interlocking shapes.

The rolls of fabric create extreme areas of overlap as well, but this time they are going in a circular direction.

Blending for Texture

You've learned how to create the texture of fabric, and you've started to see how that might apply to other surfaces. Now it's time to revisit an old theme—blending. Much of drawing depends on blending; texture is no exception. Whether you create textures using the five basic folds or aspire to create softer textures, such as the furry look of a stuffed bear, you'll need to become proficient at blending and lifting graphite. While many textures can be created using the five folds, many will depend solely on your blended pencil strokes.

You can use my blending technique to create realism in textured surfaces. The difference is using the kneaded eraser at the same time to create patterns. Previously in this book, blending was used to create smooth, continuous form. When drawing textures, the blending becomes the foundation on which you'll build the texture.

After the tones are smoothed out, you can apply more pencil lines to build up the look of the texture you are creating. For this stuffed bear, the pencil strokes were applied with short, quick strokes to represent the length of the fur. After blending with a tortillion, the kneaded eraser was used to add reflected light and dimension. The close-up shots on the following page will show you how to draw things that look furry, as well as the other various textures of the stuffed bear.

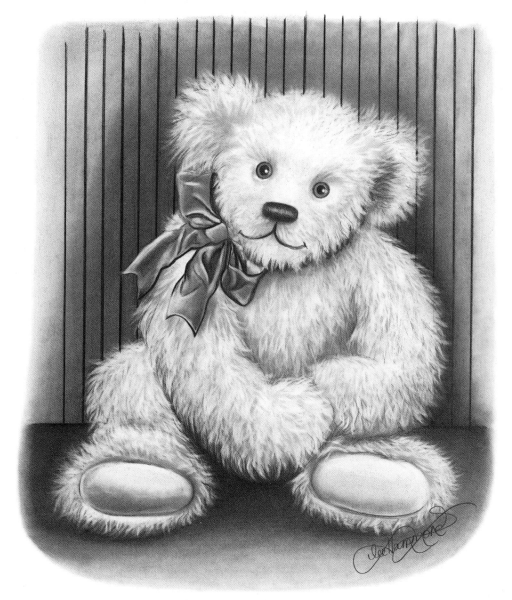

Glassy Eyes and Silky Nose

The eyes are glassy, so they must have shine and no pencil lines visible. The nose is made of embroidery thread, so it's important that the pencil lines replicate the texture. While the silkiness of the thread reflects light, the nose won't be as smooth as the eyes. The texture of the thread in the nose is entirely shown by the pencil lines. The reflected light on the nose needs to be lifted out very delicately.

Shiny Bow

If you study the bow, especially where it is bunching up at the knot, you will see the same type of tubular fold that you saw in the collar of Raggedy Ann. You will also see interlocking folds where the fabric comes out from the knotted areas. In these areas of extreme overlap, the extremes in contrast are quite obvious. Use deep black tones for the areas that recede, and lift bright areas of white for the full light areas.

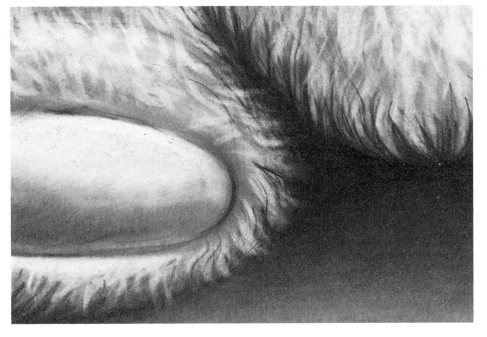

Soft, Light Fur

In this close-up of the bear's foot, you can see the illusion of the light fur. You can get the same soft and fluffy effects by adding and blending dark tone with a tortillion, then lifting light fur out against the dark tone with quick strokes using a fine-pointed kneaded eraser.

Lee's **lessons**

A dirty tortillion is the perfect way to add tone without adding pencil lines.

Blend for the Look of Leather

The patterns of light and dark on this leather boot go from being subtle, like those on the toe, to very precise, like those of the tooled leather on the side. Drawing leather is a matter of creating patterns of light and dark and depends on gradual blending. By following the basics we've already discussed, you can draw realistic-looking leather textures.

Just as you did as you drew the patterns found in glass, fill in your dark tones first and blend. Drawing the dark areas first creates the illusion of shape and form. Blending creates the smooth surface. Lifting the highlight areas gives the final touch of realism to the drawing.

Lee's lessons

For subtle light, I recommend using the kneaded eraser for a softer impression. For more control and precision, you can use the typewriter eraser and actually draw the light into your work to create accurate shapes.

Finished Leather Texture

Leather is a smooth texture. Much like creating the soft fur of the stuffed bear, you'll need to fill in your darks first, use a tortillion to smoothly blend for your halftones, and lift the lights with a kneaded eraser.

1 Create the Line Drawing and Add the Darks

Start with the shape of your object, then add dark patterns to create form. Lightly draw the pattern of the boot's design and use shading to make it stand out. The engraved pattern creates raised surfaces that have reflected light. Use the typewriter eraser to draw the reflected light along the edges of the design. Use visible pencil lines on top of the blended area to create the wrinkles of worn leather.

2 Blend the Tones and Lift the Highlights

Blend your tones to create the smooth texture of leather over the entire boot. Lift the highlights on the raised edges created by the pattern and reapply the darkest lines inside the pattern and on the wrinkles.

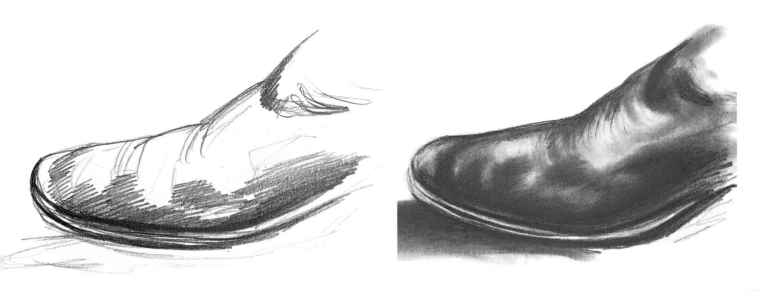

Detail Creates Realistic Textures

You've learned how to recognize the five folds in textured surfaces and you've learned to draw each of the folds individually when you see them in an object, such as a seashell. The same technique is necessary when drawing other textures with overlapping surfaces, such as bricks. At the same time, each part must fit with the others and reflect the same light source.

The hard edges and shadows of the overlapping surfaces describe the texture of these bricks. The mortar in between the bricks is white but is heavily shadowed by the bricks. The bricks' values are dark, but they have highlight areas where the light hits, too.

To properly apply those highlights, remember what you learned about perspective in chapter four. The position of each brick determines where the light hits it, which determines where you'll place the highlight.

All textures require this attention to detail, whether you're creating a basket, brick wall or pathway. Create each section or shape separately, with light edges and shadows in between. If you carefully apply your pencil lines, adding reflected light to each edge, your textures will look real.

Each Brick Reflects Light Differently

Because of the angle from which we are viewing the wall, the shapes shrink as they recede to the left. The window length appears much shorter on the left and the bricks get smaller. The top of the window edge tilts upward toward the right. The bottom windowsill tilts down. The bricks in the middle appear straight across. The bricks above those tilt up, and the ones below them tilt down. This change in angles affects the way light hits the bricks and the placement of the highlights in each brick. While the visible light is coming straight on the wall, the placement highlight on each brick differs.

Perspective Changes Shadow and Light Position

We are viewing these bricks from above, which affects the light reflection. Each brick has a light edge and a shadow creating the inside edge. These reflections are different than if we were looking at a brick wall and viewing the bricks from the side. Pay attention to these sorts of details to really bring your drawings to life.

Draw Bricks

The patterns bricks create can turn a simple drawing into an interesting piece. Bricks are made up of overlapping and touching surfaces. The techniques used to draw bricks is similar to the techniques you'd use to draw grooved paneling, baskets, stone walls, log cabins or anything created by connecting individual pieces.

1 Create the Line Drawing

Draw the outline of each brick, paying attention to the angles and perspective. Leave space between them for the mortar.

2 Fill In and Blend the Tones

Fill in the bricks with tone and blend. Add some lines to the mortar to begin creating texture.

3 Add the Darks and Lift the Lights to Finish

Create texture in the bricks by adding more dark horizontal lines. Lift light areas out with a kneaded eraser to complete them. Use a dirty tortillion to add the subtle texture of the mortar between the bricks. Use a very dirty tortillion to add random shading to those areas. Don't be too controlled; allow the graphite to appear irregular.

things to remember

- Look for the five basic folds in all fabric.
- Look for the five elements of shading when rendering folds.
- Soft edges are found where the fabric gently bends. Hard edges are created where fabric overlaps.
- Being flexible, fabric can hold many different types of folds at one time.
- Folds can be found in nonfabric textures, too.
- Blending and lifting graphite is the key to realistic texture.
- A dirty tortillion can add dark texture without adding harsh pencil lines.
- When lifting the lights, use a kneaded eraser for a softer look and a typewriter eraser for more precise lifts.

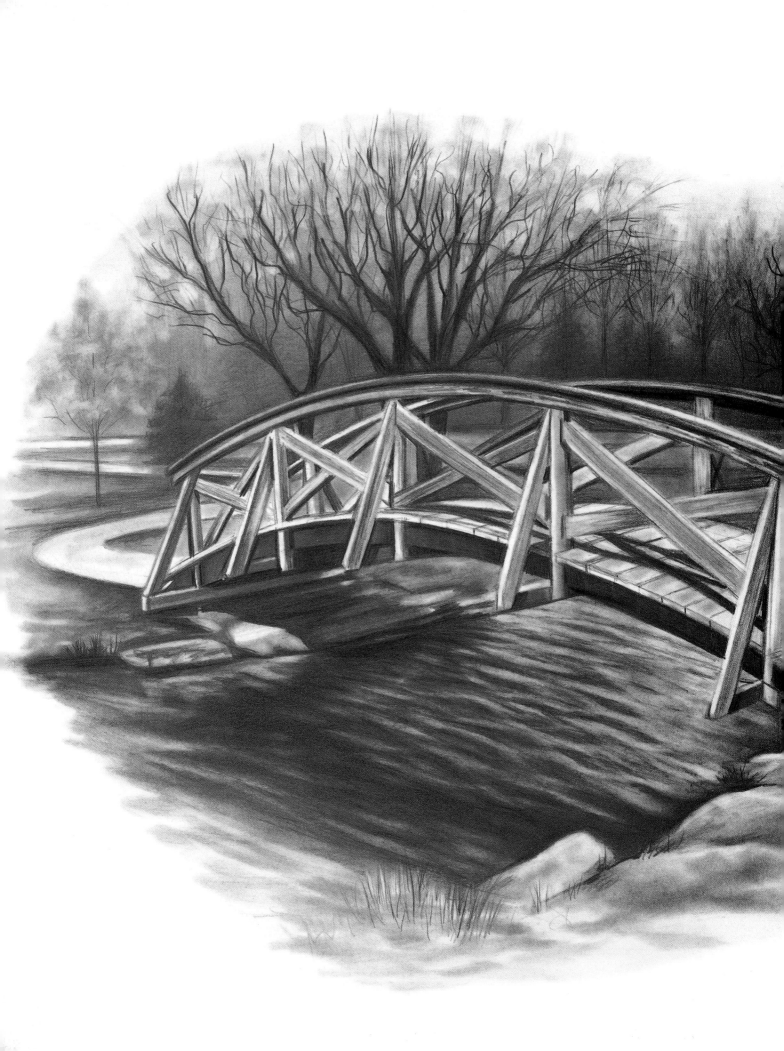

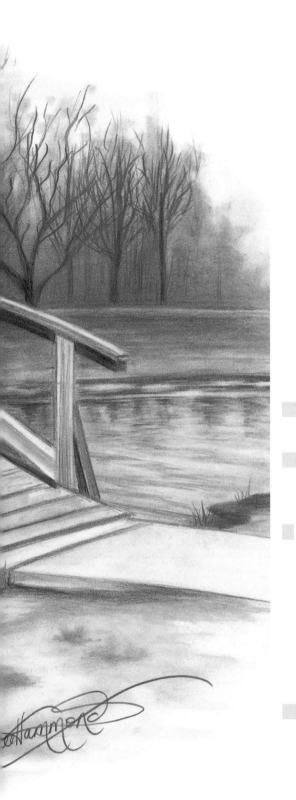

Nature

When people think of nature in artwork, they automatically think of paintings or drawings in color. While that makes sense due to all the magnificent colors that nature provides, I love to capture the essence of nature in graphite. Just like black-and-white photography creates a unique look, graphite drawings have a special look all their own. In this chapter you'll learn how to capture nature realistically and make a beautiful statement with your work.

chapter eight

Bridge
Graphite on smooth two-ply bristol paper
11" × 14" (28cm × 36cm)

How to Use Light and Dark Backgrounds

Because of the movement of sunlight, you will be dealing with different lighting situations. Sometimes the background will appear very dark and the edges of your subject will appear light against it. Other times the background will be the light area. These leaf examples show how you can use the background tones to emphasize different aspects of your drawings.

Sunlight highlights overlapping surfaces and creates reflected light. The areas of dark over light and vice versa create hard and soft edges that can give your drawings perspective and life. Textural details create additional reflected light.

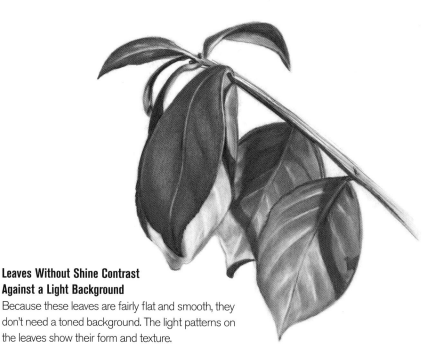

Leaves Without Shine Contrast Against a Light Background
Because these leaves are fairly flat and smooth, they don't need a toned background. The light patterns on the leaves show their form and texture.

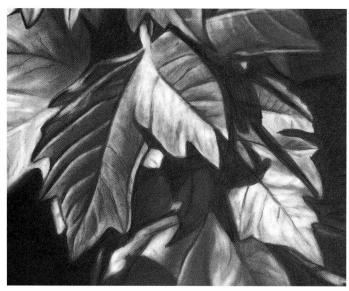

Look for Areas of Dark Over Light and Light Over Dark
Tonal overlaps, such as these lighter leaves over the more shaded ones, are common in nature and add realism and drama to your work. Here the differences in tone come from the veins of the leaves that are recessed on the front side and raised on the back. These areas always create reflected light.

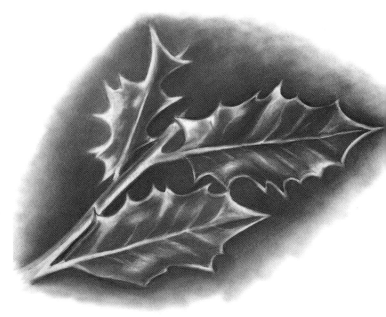

Light Edges Stand Out Against a Dark Background
Holly leaves reflect a lot of light because of their waxy nature, making their edges and veins seem to glow and requiring a darker blended background.

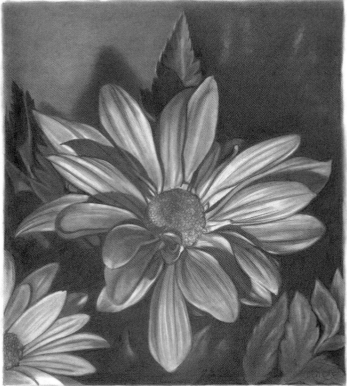

Dark Tones Create White Daisies

The extreme dark areas accent and highlight these daisies. Dark backgrounds will always make light subjects stand out and create dramatic shadows and highlights. The light seems to penetrate the petals and leaves for a very realistic quality.

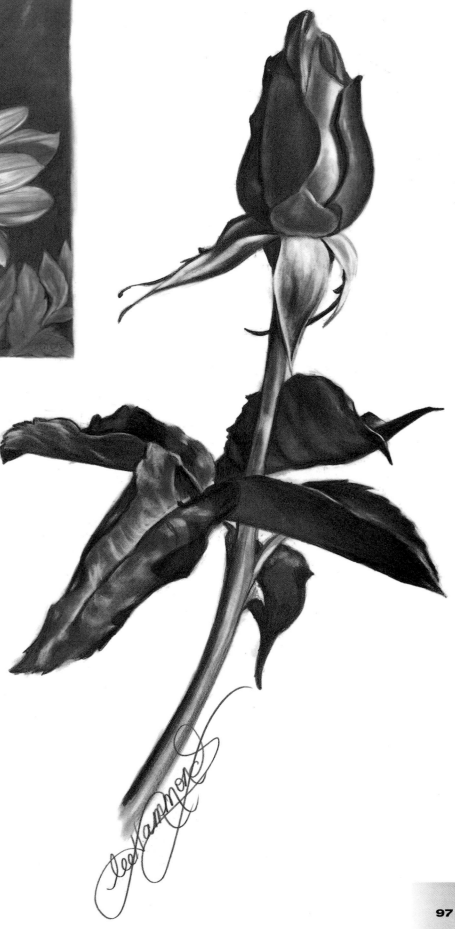

When to Omit a Background

It is not always necessary to use background treatments in your artwork. Some subjects, such as this rose, contain edges and highlights that don't require additional tones behind them. The darkness of the rose's petals creates nice edges. Using a dark background would make the rose disappear into it.

Draw a Lily Against a Dark Background

It's time now for you to see for yourself how dark tones create lights. The white lily against the dark background creates a striking yet simple drawing. Notice in the finished piece that even though the background shading is dark, it is not as dark as the darkest part of the flower stem. Both the stem and the bud are actually darker than the background. It is a subtle difference. However, it's that type of tonal contrast that is essential to realistic drawing.

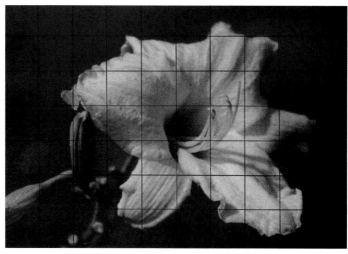

Reference Photo

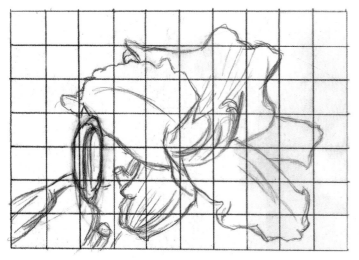

1 Create the Line Drawing

You can enlarge the object by drawing the grid boxes larger. Remember to draw your grid boxes very lightly. Then carefully draw the shapes you see in each box.

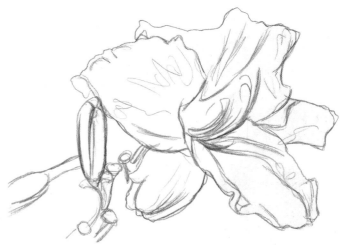

2 Remove the Grid

Carefully remove your grid with the kneaded eraser. Redraw any lines you may have lost.

3 Begin the Darkest Part of the Lily

Begin detailing the lily by adding the dark areas as well as the areas of texture.

4 Let the Background Create the Light Edges

Add the darkness to the background to create the light edges of the flower. Apply the tones as evenly as possible with the pencil. This will make the blending stage smoother.

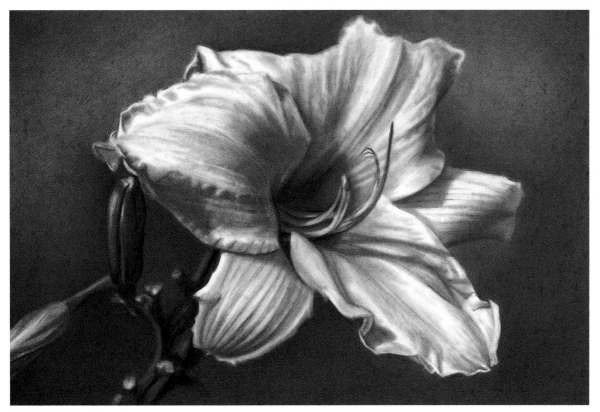

5 Finish the Drawing

Subtle tone differences make all the difference when capturing realism. Continue defining edges with your pencil for more clarity, blending out tones for smoothness and lifting highlights for realism. Take your time with this stage. Make sure your tones are accurate. Squint your eyes and compare your artwork against the photo reference, making sure your drawing is as close as possible in shapes, lights and darks.

Capturing Skies and Clouds

Nature is our largest contributor of wonderful things to draw. While I love drawing individual plants and flowers, sometimes it is nice to draw an entire scene. To do that in nature, you have to be able to render skies and clouds.

Anything can be captured in graphite, even if it is originally filled with color. By replicating the effects of the sunlight reflecting in the water and filling in the clouds realistically, our minds fill in the blanks.

We'll discuss water in the next chapter, so for now let's concentrate on skies. You can create clouds using many of the techniques you've already practiced. Identify the shapes, lights and darks. Blend the shapes and lift the lights to make the clouds look fluffy. Create the illusion of extreme distance by highly detailing objects in the foreground.

Combine Elements to Create a Sunset

You can capture the illusion of a sunset, even without color! The secret is in the position of the light in the clouds and on the water, and in the distance created by detailed trees in the foreground against a less detailed background. These things, when put together, describe the sunset.

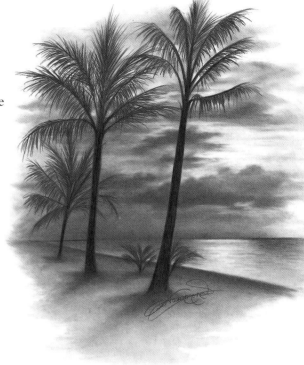

Blend and Lift to Create Clouds

The edges of the clouds were lifted against the blended shading of the sky to get the look of layers, with some clouds overlapping others. Dabbing with a kneaded eraser to randomly lift out light makes the clouds look fluffy and airy.

Lift the edges of the clouds with kneaded and typewriter erasers.

Dab with your kneaded eraser to create areas of light and dark.

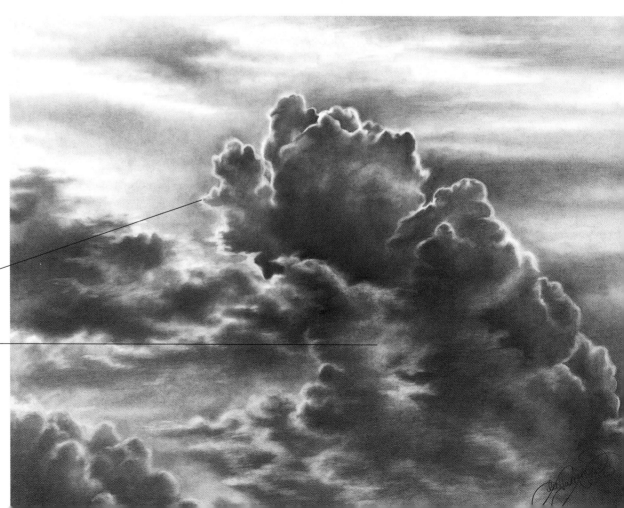

Create Clouds

Clouds are made up of patterns of light and dark shapes. Atmosphere and air flow horizontally, so make sure your pencil lines and your eraser marks follow that flow. Follow these steps to learn how to draw clouds. You will always create realistic-looking clouds using this process, regardless of the shape of the cloud.

1 Begin the Drawing

Lightly draw in the shapes of the cloud patterns. Apply some shading to the background with a dirty tortillion.

2 Add the Darks

Add some darker tones into the pattern shapes. Apply the pencil lines in a horizontal fashion to represent air direction.

3 Darken, Lift and Blend to Finish

Deepen the dark tones. Now the light edges of the clouds stand out. Intensify the light by dabbing it out with a kneaded eraser. Blend everything to keep the clouds looking smooth and fluffy.

Draw Grass and Rocks

You can draw realistic-looking grass and rocks using the skills you've been practicing already—capturing shapes, adding the darks, blending for halftones and lifting the light. Drawing grass is as simple as using quick strokes with your pencil, and rocks require the smooth gradual blending you've been working on throughout the book.

Lee's lessons

Create thick grass around your trees or other objects with alternating pencil and eraser lines.

1 Create the Line Drawing

Lightly draw the shapes of the rocks. This can be done freehand. When drawing nature, it is not necessary to be as accurate as you need to be with more defined subject matter. Loosely depict the shapes of the rocks, the waterline and the bush.

2 Fill In the Darks

Place the darkest tones in the shadow areas and where the dark grass contrasts against the light-colored rocks. Use quick strokes to represent the grass sticking out from behind and in between the rocks. Place some tone under the rock in the water. Water reflections are like mirror images and are always directly below the object being reflected. Water moves horizontally, so use horizontal lines to describe the reflections.

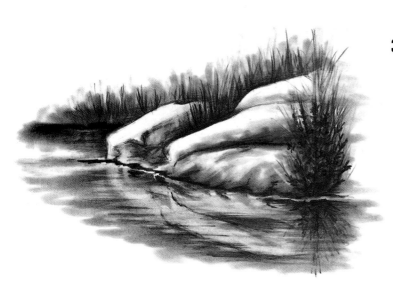

3 Add the Finishing Touches

Deepen the tones in the water and rocks to bring out the lights and create the illusion of direct sunlight. Gently blend with your tortillion to make the texture of the rocks smooth. Move your tortillion horizontally along the water and add more pencil lines to make it look streaky. Create the shine of the water by lifting horizontal streaks of light with a kneaded eraser.

Add quick strokes to the grassy bush in front of the rocks for the little branches. Use small, squiggly lines to imitate the look of small leaves. Lift a small, irregular white line along the water's edge with a typewriter eraser to separate the water from the shore.

Creating Trees

A pinecone is another item in nature with many overlapping surfaces. Many of the techniques you would use to create this pinecone are identical to those you would use to draw a tree, so we'll use this example to introduce you to trees.

Notice the pinecone's shadow. The texture of the ground can often be described best in the cast shadow area. While it's difficult to create definite shapes unless you control the eraser like a pencil, dabbing with the eraser to pull up those areas of light gives the shadow a more random look. And when drawing nature, you often need that random, irregular appearance.

Remember this when you begin drawing trees and landscapes. The same technique can be used to create foliage.

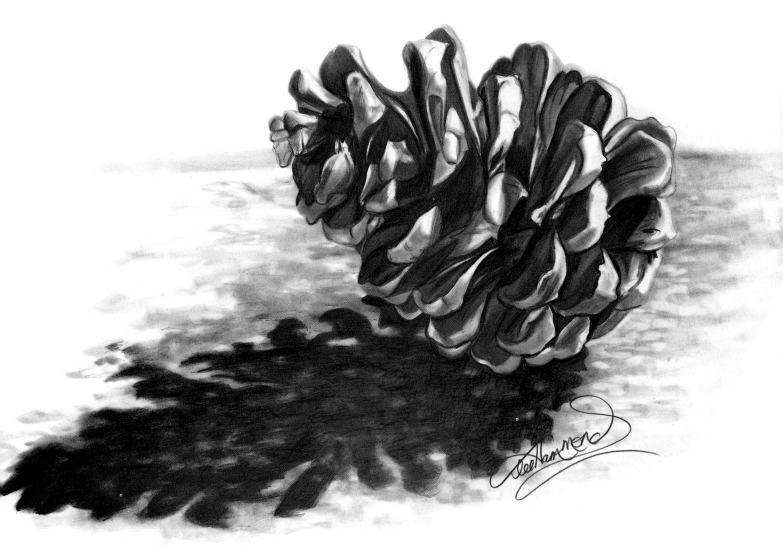

Use a Kneaded Eraser to Create Irregular Texture
Dab with the kneaded eraser to create the illusion of texture. The random nature of the dabbing creates a more natural look. Shadows are important when depicting nature and help describe the entire scene. The cast shadow describes the ground that the pinecone rests on as well as the shape of the pinecone. This technique is useful to create foliage and trees, too.

Draw a Tree With Foliage

When you're drawing trees, foliage can be difficult. Many students make the mistake of trying to draw each individual leaf. The task becomes easier if you view the leaves as clumps, which create patterns of light and dark shapes similar to those you saw on the pinecone and in the pinecone's cast shadow. Follow the step-by-step exercise to learn how to draw a tree in full leaf.

1 Create the Line Drawing

The line drawing may not look like much yet, but it is the foundation of things to come. Draw nonsense shapes to designate areas of light and dark.

2 Begin to Fill In the Tones

Use a circular motion with your pencil to fill the tones into the pattern shapes. Vary their tones, with each one being a little lighter or darker than the other.

3 Create the Grays and Add the Shadow

Continue filling in the patterns. With your tortillion, blend out the various tones to create some gray areas. Add the shadow below the tree to make it appear firmly grounded. It isn't pretty yet but is starting to take on more realism.

4 Darken the Darks, Dab the Light Areas and Deepen the Shadow to Finish

Intensify the dark areas to create more depth. Use your kneaded eraser to dab out the irregular light areas. This creates the look of foliage layers with the sunlight bouncing off them. Deepen the shadow below and shade down from the horizon line to help create the look of distance.

Create Depth and Distance

When we talked about perspective with the train tracks or roads in chapter four, you saw that the road seems to get smaller as it gets farther away. That's one way to create distance. Objects farther away diminish in size.

Objects also diminish in detail with distance. Trees are excellent tools to demonstrate this. Adding detail to foreground trees and losing detail in background trees instantly creates distance.

Another way to create depth and distance in your work is with *atmospheric perspective*. This is when things in the background appear lighter than those in the foreground. The silhouette of the closer trees against the blended trees makes the blended ones seem farther away.

Lee's lessons

The farther away something is, the more of the sky color it takes on. In black-and-white drawing, this means objects in the background appear lighter and more gray.

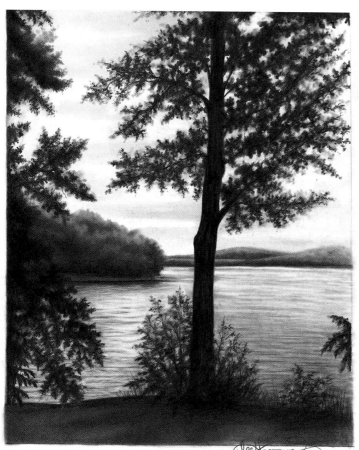

Use Size and Detail to Show Distance
Notice how much smaller and ill-defined the trees in the background are. The foliage of the trees in the foreground displays details and texture, while the foliage in the background is blurred.

Use tight, circular pencil strokes to create the clumps of leaves in both the foreground and the background trees. Use your tortillion to blend the background trees well. Lightly smudge the lines in the foreground trees just enough to make them appear less harsh.

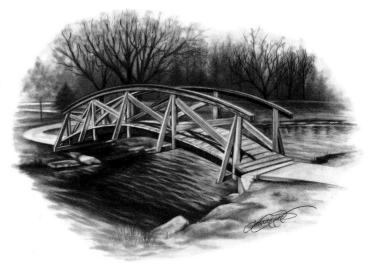

Create Depth and Distance in a Scene
The defined silhouette of the trees against the blurry images of the blended ones creates distance. The defined grass in the foreground, created with quick pencil strokes, suggests closeness. The detailed grass makes you feel like you are standing in the foreground of the picture.

Notice too, how the sidewalk shrinks as it recedes into the background. The sidewalk is wide on the right side of the drawing, where it is the closest, and is much smaller where it continues on the left side of the bridge. Things recede in the distance.

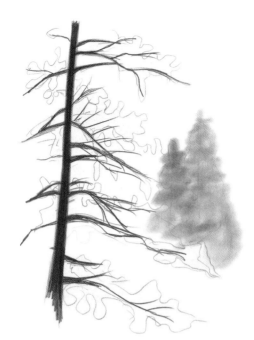

Easy Tree Perspective

Begin with the blurred impression of the trees in the background. Draw a very light outline of the trees followed by a very dirty tortillion to fill in the shapes to just give the impression of trees.

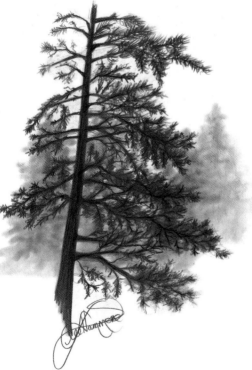

Add Detail to Foreground Trees

Lots of detail in the foreground tree drawn over the trees in the back seals the perspective. Completely fill in the trunk and the limbs. Make them as dark as you can. Small lines represent the pine needles.

Lighter Objects Appear Farther Away

There is little or no discernable difference in size among the trees in this drawing. Atmospheric perspective was used to give the look of fog and mist, making the lighter trees seem farther away. You can draw the lighter trees with a dirty tortillion.

Draw a Windmill Scene

In this demonstration we'll combine elements we've covered before, such as creating the illusion of distance through tones and detail and drawing metal. The cloudy appearance in the background is light and blended with a tortillion, providing depth. The trees in front will be dark and full of texture, making them appear closer.

However, one of the most important lessons in this drawing is the use of *lost* *edges*. This is where an edge seems to almost disappear into the surrounding areas, like the blades of the windmill on the right side. The sunlight makes them so light in tone that they blend into the color of the sky.

The windmill itself calls for more precision in your shapes, requiring you to use a ruler. This precise, geometric approach will contrast sharply against the looser style used to create the rest of the drawing.

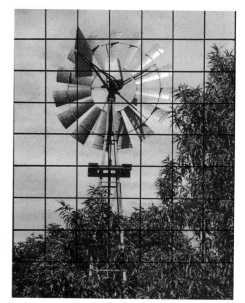

Reference Photo

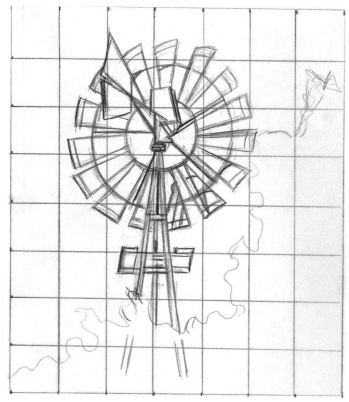

1 Create the Line Drawing

Using the graphed photo, create a line drawing of the windmill. Be as accurate as possible within the grid lines. Be careful drawing the angles and edges of the blades. While they don't make a perfect circle, it helps to imagine a circle as a guide as you draw.

2 Remove the Grid and Add the Darks

Carefully remove the grid lines from your drawing. Add tone in the darkest areas on the lower left of the windmill. The lighter areas on the upper right side should almost disappear into the sky because the blades are so light. Their edges should seem lost. This is an important feature to capture when drawing realistically. Do not outline things to compensate for vague edges; allow them to appear subtle or even disappear completely.

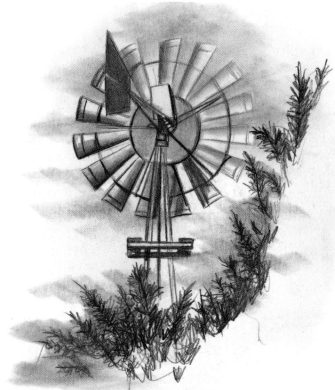

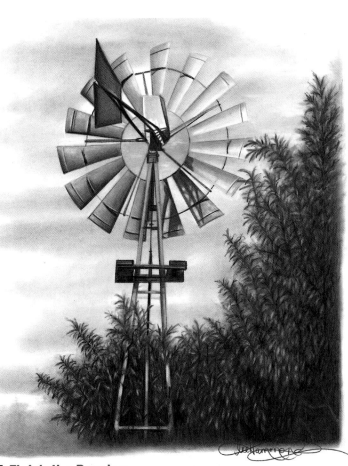

3 Add the Shadows and Place the Foliage

Continue adding tones to develop the drawing. Add the shadows on the blades. Begin placing the dark foliage in front of the windmill. This helps create distance and acts like a natural framework for the drawing. Use your tortillion to add some subtle blending behind the windmill to gently create the edges of the windmill blades.

4 Finish the Drawing

Continue to fill in the trees to intensify the darkness and texture. Make distinct shapes with your pencil to create the look of leaves. Use a kneaded eraser to lift out the light leaves and make the trees look textured. Blend the blades on the windmill to make them look metallic (review chapter six for a refresher on metal). Lift light there, too, to make them appear shiny.

things to remember

- Use light backgrounds to emphasize leaves without shine and dark backgrounds to highlight more reflective foliage.

- You will find many overlapping surfaces in nature.

- Dab with your kneaded eraser to lift light in nature.

- To establish distance, keep foreground objects in focus and background areas less detailed.

- When drawing trees, view the leaves as patterns of light and dark shapes rather than individual leaves.

- Squint when looking at a reference photo to see the patterns of light and dark created by foliage.

- Allow lost edges, or edges that seem to disappear into the surrounding areas, to remain subtle. Do not outline them.

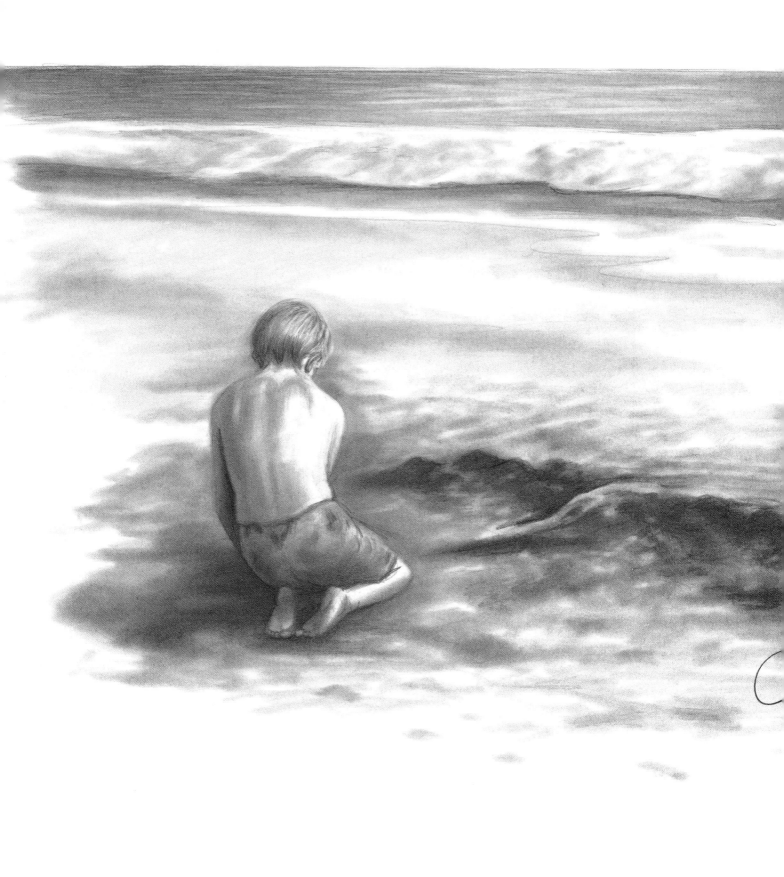

Water

Drawing water is a challenge not because it's difficult but because of the way we think about it. When we think of water, our minds know that it is transparent. This information that is stored in our heads interferes when we begin to draw, confusing the issue. Drawing water is just like drawing glass. It's made up of the light and dark tones reflecting into it. It is nothing more than a collection of light and dark patterns and random shapes, like a puzzle.

Criffy at the Ocean
Graphite on smooth two-ply bristol paper
11" × 14" (28cm × 36cm)

Water Droplets Are Spheres

To draw water droplets, you'll combine what you know about drawing spheres and glass. Each droplet reflects its surroundings just like a glass surface. Because each drop is separate and raised from the surface, it becomes another sphere exercise.

The cast shadow below each droplet is clearly visible, as is the shadow edge and reflected light. Because of the highly reflective nature of water, the contrasts are extreme.

Water Droplets on a Pear
Each droplet of water is a separate sphere exercise. The droplets are defined by the cast shadows on the pear's surface.

Dark Leaves Accentuate Reflective Droplets
Place water droplets on deepened tones such as the rose's leaves to make them seem more reflective. The lights of each drop really contrast with the leaves. Don't forget the cast shadows!

Draw Water Droplets

Your skills with basic shapes will help you draw water. Drawing water droplets is nothing more than reflective sphere exercises that contain patterns of light and dark. Here, the darkness of the leaves helps the droplets stand out. Concentrate on accentuating the dark and light contrasts when depicting wet objects.

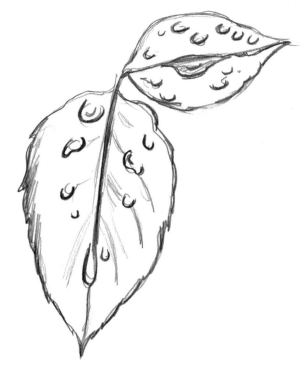

1 Create the Line Drawing

Draw the outline of the leaf along with the veins and droplets.

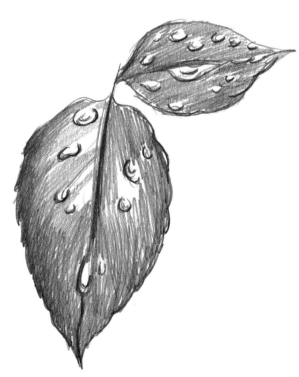

2 Add the Tones and Shadow Edges

Add the tones of the leaves with your pencil. Place dark tones on the center vein and underneath each water drop. Fill in the shadow edge inside of each drop.

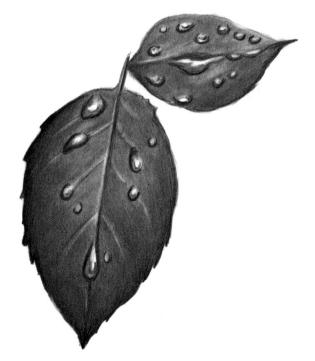

3 Deepen and Blend the Tones

Deepen the tones of the leaves and blend with a tortillion. Add some shading to the droplets and deepen the shadows below them. Lift reflective light out of the droplets and in the veins of the leaves

Drawing Water Surfaces and Waves

You learned to use the the lifting technique to create clouds in chapter eight. This technique is useful when creating water as well. Drawing water is similar to drawing clouds for two reasons. First, like clouds, water contains patterns of light and dark shapes. Second, water moves horizontally, just like atmosphere and air.

The reflective nature of water sets it apart from clouds. Your challenge is to describe water's movement along with its reflectiveness. Depending on the wind, the water's surface can appear smooth as glass or very choppy, which creates the different water patterns. You must include the water's patterns along with the reflections.

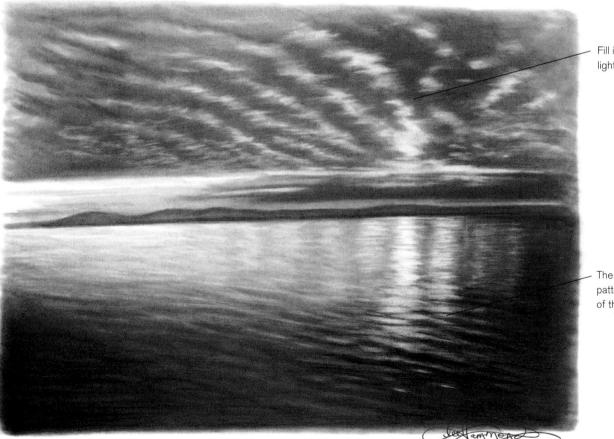

Fill in shapes and lift lights for realistic clouds.

The water consists of patterns and reflections of the clouds above.

Create Water Surfaces With Patterns and Blending

Notice how patterns of the clouds reflect into the water in this illustration. The skills you gained when drawing glass combined with the techniques you learned drawing clouds will help you with water. Use the same dabbing and blending techniques with water, but increase them. Achieve the smooth look of water with increased blending, especially in the dark areas.

Rough Water

When water is choppy, the patterns of light and dark appear as little triangular shapes. The pointy tops of the shapes give the illusion of rough water conditions. After drawing in the triangular shapes, blend and lift out similar shapes with your typewriter eraser.

Calm Water

When water is fairly smooth, it still is made up of light and dark patterns. These shapes look more like flat ovals. The water looks smoother than the previous example, but the drawing process is the same.

Draw Breaking Waves

When a wave breaks on the shore, the patterns show more concentrated movement. The pencil lines represent the movement and direction of the wave in this demonstration.

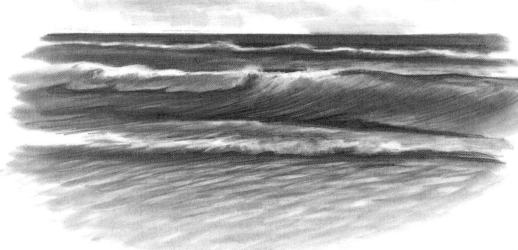

Waves Are Patterns and Layers of Darks and Lights
Look at the layers of darks and lights. The dark horizon line in the background makes each wave layer show up. Notice how there is an area of calm or smooth water between the waves. Lift out whitecaps with your kneaded and typewriter erasers. Repeat the steps for the wave's detail to create beach scenes of your own.

1 Begin the Wave Shapes

With a ruler, create the horizon line. This is always horizontal and parallel to the edge of the paper. The horizon line, when viewed on water, is never curved or tilted. At this stage you're creating the distance and layers of the water with line.

2 Add the Darks

Begin placing the tones into the darkest areas of the water. Make your pencil lines go with the flow of the water as it comes to shore. This is extremely important. If you place lines that are straight across or too up and down, it disrupts the direction of the water's movement. Any pencil lines that are visible to the eye *must* be consistent to the shape or texture of what you're drawing.

3 Blend the Tones and Lift the Lights

Continue to deepen the tones. Make the base of each wave and along the horizon line extremely dark. Leave the light areas that represent the light reflections and the whitecaps light. Then lift them out further with a kneaded eraser. Draw in the gentle streaking of the light areas in the waves with a pointy piece of eraser.

Create Water Reflections

Much like glass, water's reflections give away much of its form. When drawing reflections in water, it's vitally important to make sure that the reflections are directly below the subject and to include the shapes and streaks.

Sometimes my students become confused when addressing shadows and reflections. Shadows are altered by the light source. You've probably noticed how a midday shadow seems short, then as the light becomes lower, the shadow stretches out.

With water reflections, the reflection never stretches out. It's always directly below the object that is being reflected. The water's movement may interrupt the image, making it appear broken up into segments. But, even when this happens, the segments are still directly below the object. The horizontal streaks and shapes tell you that this is water, because water is always moving.

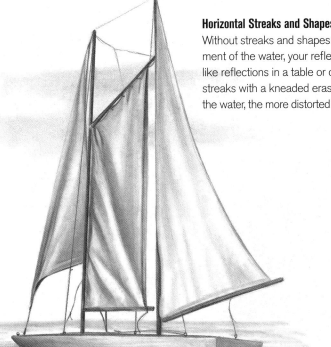

Horizontal Streaks and Shapes Show Moving Water
Without streaks and shapes to show the movement of the water, your reflections will look more like reflections in a table or other surface. Create streaks with a kneaded eraser. The more active the water, the more distorted the reflection will be.

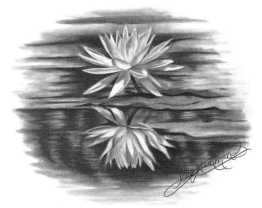

Calm Water Produces a Near-Mirror Image
While still water can make it look like two objects are stacked together, there are still slight streaks to show the water's slight movement.

Place Water Reflections Directly Below the Subject
Reflections in water such as these are always directly below the subject in a mirror image.

117

Draw Realistic Water Reflections

This drawing of a swan on the water shows that, unlike shadows that can stretch out from an object due to the light source, water reflections are always directly below the object in a mirror image. Because of the moving surface of the water, the image is broken up into horizontal strips of light and dark.

1 Create the Line Drawing and Framework

Lightly draw the shape of the swan, then add a horizon line to depict the shoreline. Add some dark tone in the background to create distance and contrast against the white of the swan. Also add some horizontal lines to the water to start the beginning of the reflections.

2 Develop the Darks

Develop dark tones throughout the drawing. Make sure that all your lines in the water area are horizontal, leaving the light areas white to describe the shape of the reflected swan.

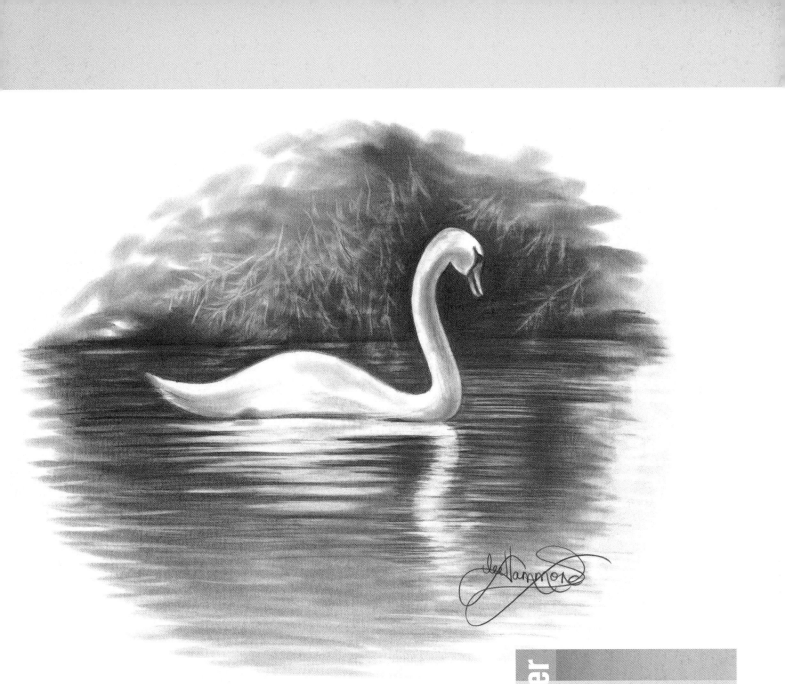

3 Blend, Add and Lift Tone to Finish

Blend everything to a smooth tone with your tortillion, then add more dark. Also add some tone to the neck of the swan; can you see the cylinder shape? Finish detailing the face and beak.

Create the illusion of foliage and vines in the background by lifting out the light lines with a typewriter eraser and kneaded eraser.

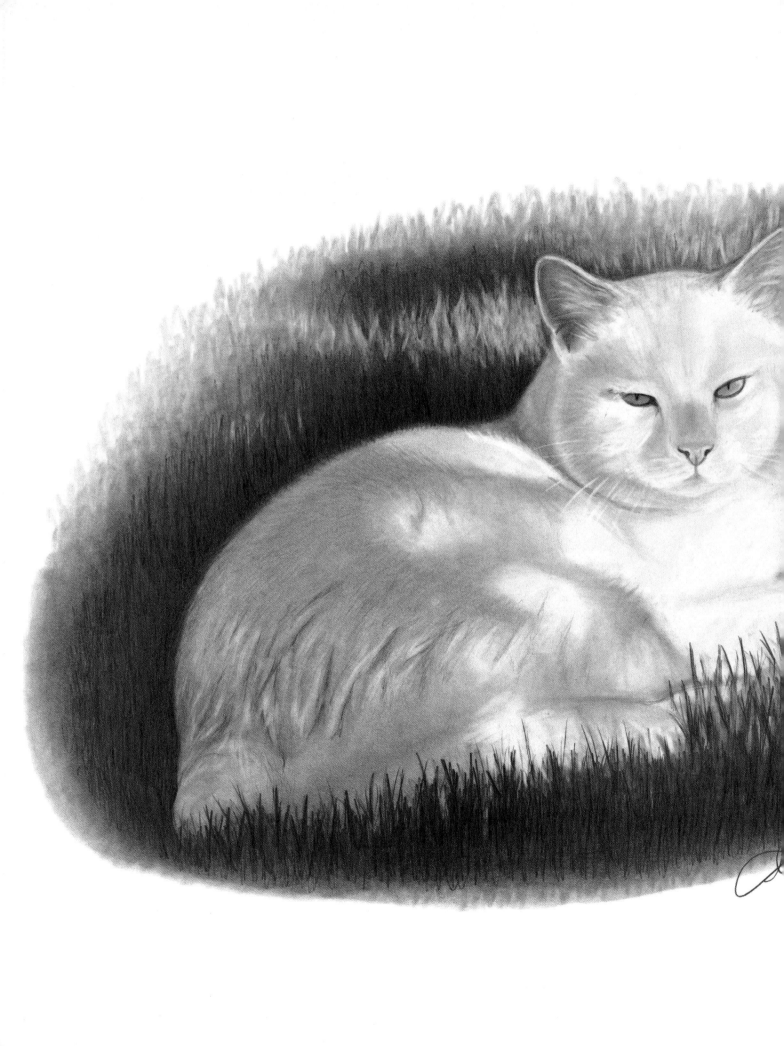

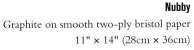

Animals

Drawing animals provides an artist with many different drawing challenges. Because of the various colors and textures that most animals have, capturing them realistically requires different techniques. Like perspective, the art of drawing animals really requires an entire book. But the skills you've learned with texture, nature and even transparent surfaces will give added life to your drawings of animals and wildlife. Graphite provides unparalleled realism when rendering fur and hair.

chapter ten

Nubby
Graphite on smooth two-ply bristol paper
11" × 14" (28cm × 36cm)

Draw Realistic Animal Fur

My dog and best friend, Penny, introduces you to one of the main animal challenges. While previous chapters have helped you master the blending technique, drawing hair and fur is something new. Penny's fur is a combination of long and short hair, along with various colors mixed together. To render her unique appearance, you will need both smooth blending in her face and eyes as well as visible pencil lines to create the look of long fur.

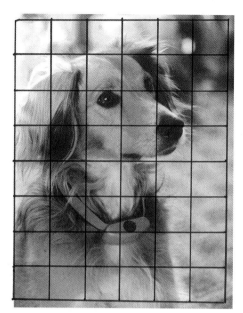

Reference Photo

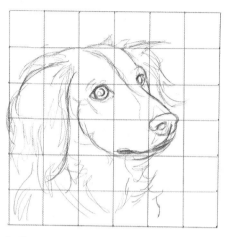

1 Create the Line Drawing in the Grid

Lightly draw the 36-box grid and draw the shapes you see inside each box. Focus on the top three-fourths of the photo.

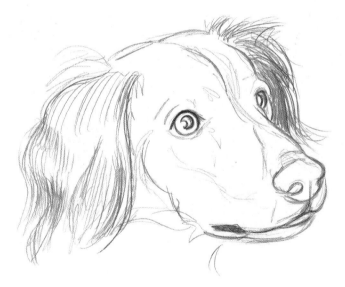

2 Begin the Details and Facial Features

Carefully erase your grid lines. Add long pencil lines to the ears. The length of your lines will represent the length of the hair strands. Begin to darken the lines in the eye, mouth and nose areas.

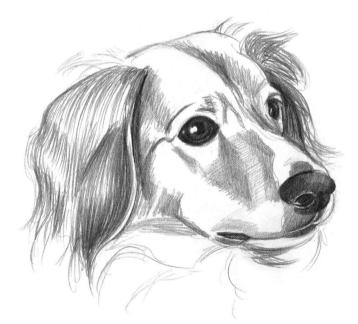

3 Fill In the Dark Tones on the Nose and the Eyes

Leave reflected areas of light on the nose and the eyes, because these areas are moist and shiny. The whites of Penny's eyes will hardly be visible. Continue filling in the ears with long pencil strokes. Add some tone to the face with smaller strokes. This hair is very short, and it will be seen as shading as opposed to texture.

4 Add, Blend and Lift the Tones

Continue adding tones, then blend with the tortillion to smooth them. Reapply the pencil strands to the ears for texture. Form your kneaded eraser into a point and lift light hair strands with quick strokes. Reshape your eraser after two or three swipes. (Don't worry, this takes practice. If you lift out too much, just fill it back in with your pencil.) Lift out the highlight areas of the face with the eraser as well.

A Fuller View
This shows what the tortillion and kneaded eraser can do! The same techniques that you just practiced to create a realistic drawing of my dog's face will help you create a complete drawing like this one.

Drawing of Penny
Graphite on smooth two-ply bristol paper
14" × 11" (36cm × 28cm)

Smooth Versus Rough Texture

Creating texture, smooth or rough, requires blending. You can duplicate the look of shiny, smooth fur by blending out any lines and lifting light. Very smooth fur should shine.

Rough-textured skin and fur has blended tones as well. After you finish blending for form, you'll have to allow the small pencil lines to do their work to create the rough textures. Use the kneaded eraser to lift highlights and further develop the texture.

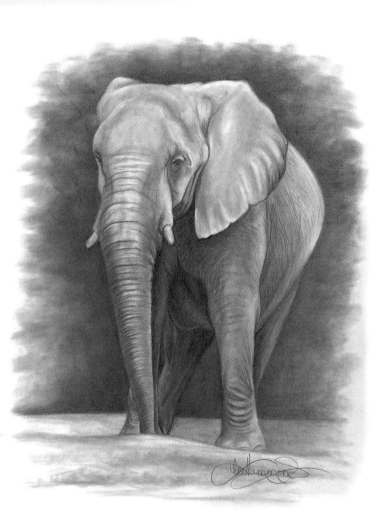

Rough Skin
Small pencil lines create the wrinkled, weathered look of the elephant's skin. Remember the five elements of shading; light hits the top of each elephant wrinkle.

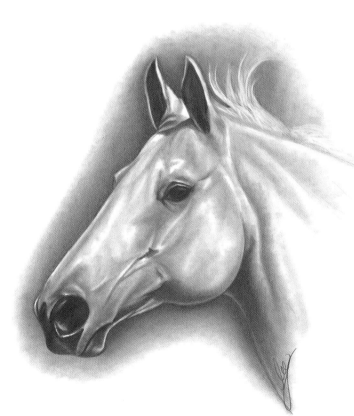

Smooth Fur
Graphite can produce very smooth tones. White subjects still require shading to represent form. Sometimes, the more shading you apply, the whiter the subject appears. This portrait of a horse shows the beautiful smoothness of the horse's fur. The background shading makes the white fur stand out, but notice how little of the drawing is actually left white.

Lee's lessons

When drawing, white isn't just white and black isn't just black. White objects need shading to show form. Sometimes the more shading you use, the whiter your subject can actually look. Black objects need highlights to show form.

Draw a Prairie Dog

The prairie dog's fur is fairly smooth. In this drawing, you'll learn how to use background and highlights to accentuate the texture of fur. The bright highlights show where the light source is. The darkness of his tunnel helps him stand out.

Use quick pencil lines and quick lifts with the kneaded eraser to create his fur. Use a dirty tortillion to draw the rocks around him to keep them out of focus and not distracting.

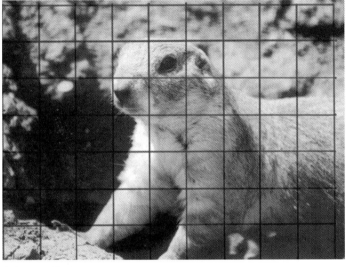

Reference Photo

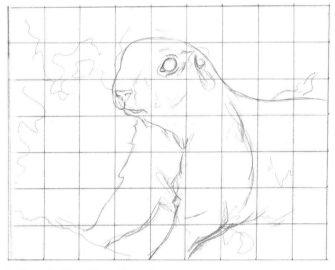

1 Create the Line Drawing

Using the graphed photo, draw an accurate line drawing of the prairie dog. Remember to reproduce the shapes you see in each box. Pay attention to the shapes rather than the overall image.

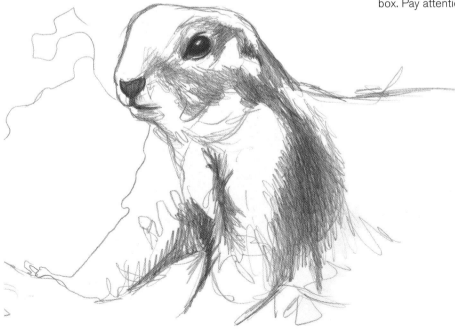

2 Remove the Grid and Add the Darks and Texture

Carefully remove the grid lines from your line drawing. Begin with the darkest areas, adding tone to the eyes, nose and shadow areas. Your pencil lines should represent the texture and direction of the fur.

125

3 Fill In the Background and Create Texture

Add the dark background to help create and define the light edges of the prairie dog. Blend with the tortillion to replicate the softness of the fur, then lightly reapply pencil lines to create texture. If you blend out too much texture, simply reapply the pencil lines again.

Use the kneaded eraser to lift out light areas on the prairie dog to give the illusion of random sunlight and additional texture.

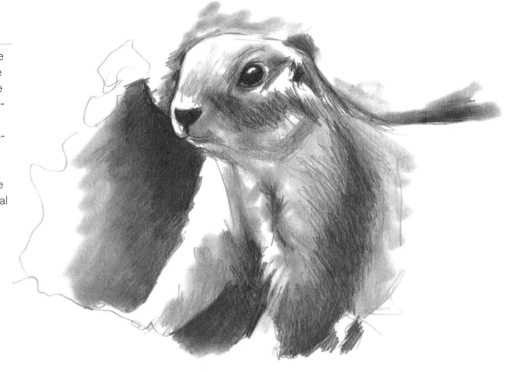

4 Add the Tone and Blend to Finish

Continue to blend and add pencil marks to the prairie dog to replicate the look of his fur. Use a dirty tortillion to draw the rocks. You want to keep the focus on the animal, so keep the rocks very subtle.

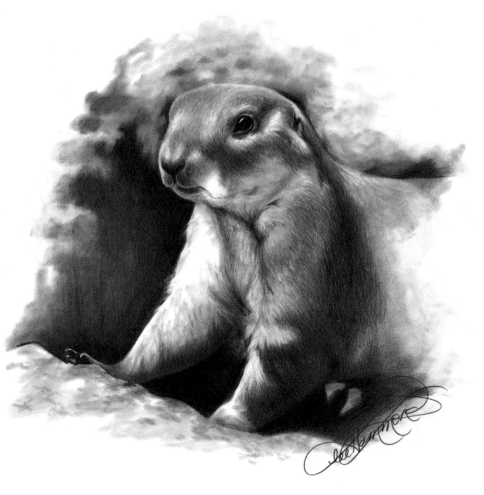

How to Draw Winged Creatures

A creature with fur will require a lot of pencil lines to create that particular texture. Creatures with wings, such as butterflies and birds, will have areas of colorful patterns that must be drawn like a puzzle. Birds' feathers will have layers of overlapping surfaces, which will require edges including shadows and reflected light.

This may seem overwhelming to a beginning artist, but practice makes it second nature. The day finally comes when you can stop asking yourself, "How do I draw that?" and instead start asking, "What shall I draw?"

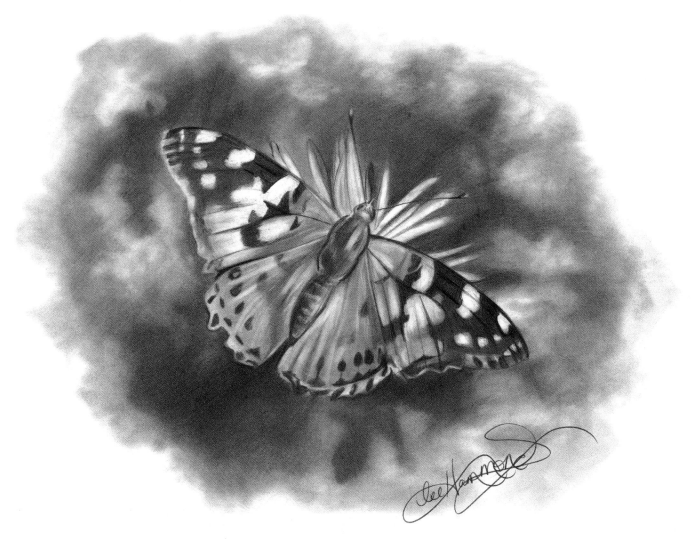

A Blurred Background Focuses Attention on a Beautiful Subject

Even the brightly colored butterfly can be beautifully drawn with graphite. Just like you created a dark background and blurry surroundings to bring focus to the prairie dog, a blurred background brings to life the patterns generally found on bird and butterfly wings. By blending everything out in the background, your full attention is directed to the butterfly, just as your own vision would see it. Then concentrate on creating the shapes and tones in the butterfly.

Patterns Create a Butterfly

Butterflies are beautiful, even in black and white. The unique patterns on their delicate wings always make a lively drawing. Using the grid method, you can capture the patterns' shapes easily.

By blurring the image of the lilac flowers in the background and adding detail to the flowers in the foreground, you'll create distance and direct focus to the butterfly.

Reference Photo

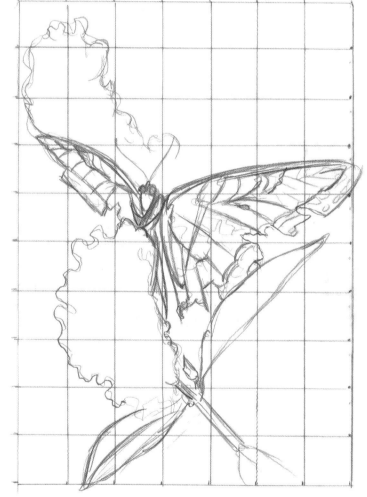

1 Create the Line Drawing

Use the reference photo and grid to create a line drawing of the butterfly. Remember to focus on the shapes in each block.

2 Carefully Remove the Grid and Redraw the Wing Patterns

Once you are sure that you have achieved an accurate line drawing, carefully erase your grid lines and redraw the patterns of the butterfly wings to make them more distinct. This is the most important aspect of the drawing.

3 Fill In the Darks and Create the Flower Details

Begin filling in the dark patterns on the wings. At this stage, the butterfly is already appearing realistic.

With your pencil and a dirty tortillion, add and blend some tone in the background to create the shape of the lilacs. Begin adding dark details to the flowers in the front with your pencil. Create the round, circular shapes of the individual flowers.

4 Add the Tones and Blend to Finish the Drawing

Continue adding darkness to the flowers in the front. Blend the side on the right, directly under the butterfly. This helps create the light source. With the kneaded eraser, lift and dab light out of the flowers, both in front and in the background.

Add the shadow to the underside of the butterfly for realism. Add tone to the leaves and blend it in. Reapply the dark lines of the veins and lift the light to create the highlight areas.

Drawing Birds

Birds are fun to draw. However, keep in mind that their feathers create vastly different textures. The layers that their feathers create are similar to flower petals, where each edge needs to be drawn individually.

Every species of bird has a unique type of feather and pattern. Some have very distinct feathers, while others are more subtle.

There are different types of feathers on each bird, as well. In some areas, the feathers are very long, like in the wings and tail. This helps a bird to fly. Sometimes the feathers on a bird will seem more like down, fluff or fur, as seen on the owl head. This makes it even more important to capture the patterns of their markings, much like you did with the butterfly.

Shading Creates White Hawk Feathers

This hawk has none of the markings seen on the owl. Its feathers are white, so the layers are created by the use of light and shading. A darkened background makes the bird seem white, but shadows on the bird depict the light source as well as the hawk's form. Treat each feather individually, including the five elements of shading.

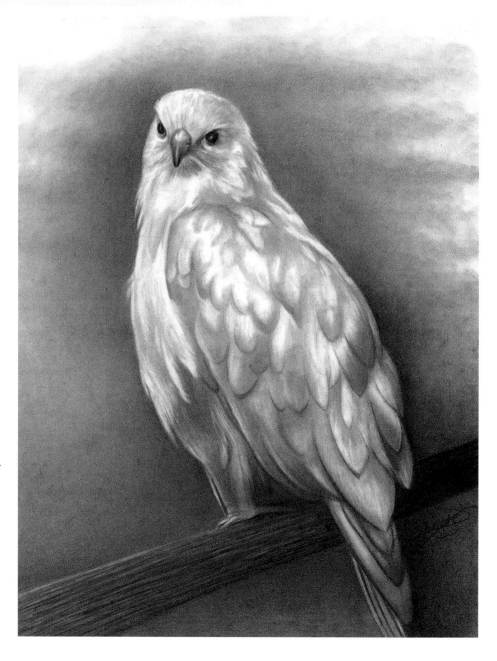

Create Fur-like Owl Feathers With Blending and Patterns

The owl's smooth, shiny eyes and beak contrast against the textured surface of his head. On his head, he's fluffier and more fur-like, rather than having discernable feathers. Use blending and lifting, like you did on the furry animals. Follow the owl's patterns and use pencil lines to help create the patterns of light and dark. You can rely more on the five elements of shading around his wing area where the feathers are more distinct, like the hawk's.

demonstration

Draw the Fur-Like Features of an Owl

The feathers on the owl's face are short and not distinct, resembling the look of fur. The lights and darks represent the color and markings of the feathers, not the feathers individually.

Using the photo and the grid method, follow this step-by-step demonstration to create a drawing of an owl.

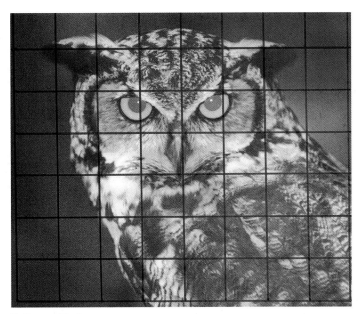

Reference Photo

1 Create the Line Drawing

This reference photo has been divided into 56 equal squares. Draw the squares lightly on your drawing paper and draw what you see in each box. Be sure to capture the many dark and light patterns on the owl. When your drawing looks like this one, gently remove the grid lines with your kneaded eraser.

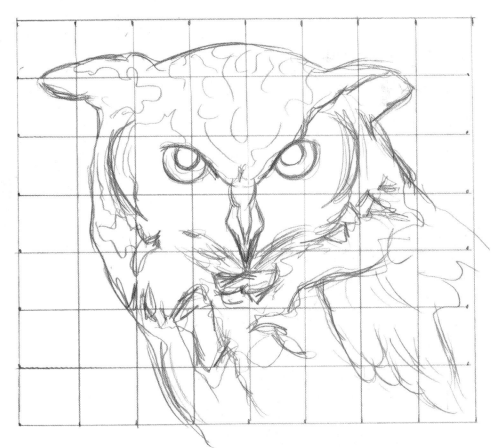

2 Fill In the Eyes and Darkest Areas

Begin filling in the pupils of the eye. The eyes will need to be black—your darkest dark. Be sure to leave a white spot for the catchlight. Start filling in all the dark areas, like the inside area of the ears.

3 Continue Adding Darks and Develop the Head

Continue adding dark tones to the drawing. Create the patterns on the top of the head using the same technique you would for a cat or a dog. This area looks more like fur than feathers.

Develop the tones and markings on the face as well. Gently blend some tone into the iris of the eye with a tortillion.

Lee's lessons

Eyes are shiny whether they are human, animal, reptile or bird. Because they are wet, their reflections are intense. A *catchlight* is the shiny white spot you see in eyes. It is a reflection of the light source. To keep it from interrupting the gaze and direction the eye is looking, move the catchlight so it is half in the pupil (the black area) and half in the iris (the colored area). Place it in the same spot on both eyes.

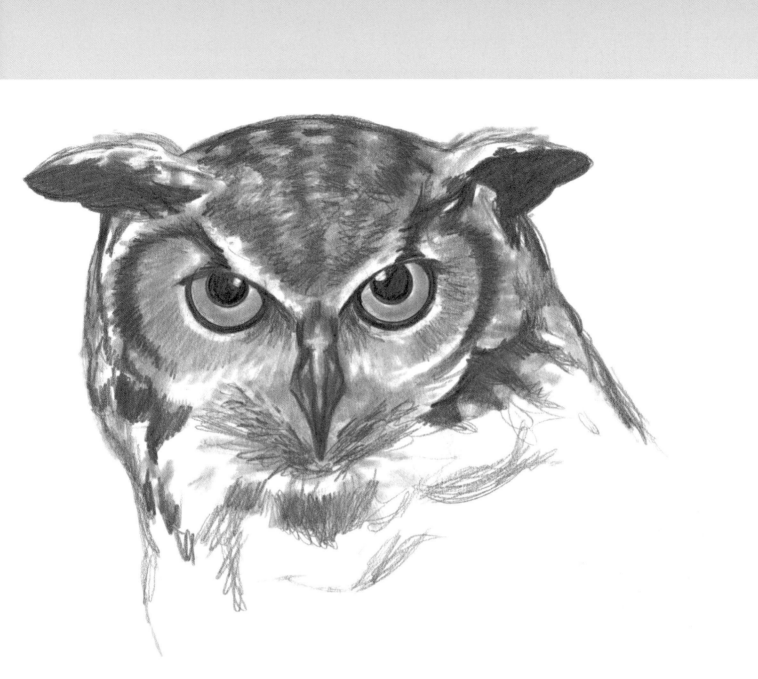

4 Blend, Lift and Add for Texture

Blend the tones with the tortillion, and then continue deepening them with your pencil. Use the kneaded eraser to lift out light areas and add small pencil lines to create the look of texture.

Draw the Feathers of a Hawk

Drawing this hawk is very similar to drawing the owl. You'll use the same techniques. However, because the feathers are white, we don't have to deal with markings and various colors. Instead, we must look at the patterns that the shadows create on the white bird and see the shadows as shapes.

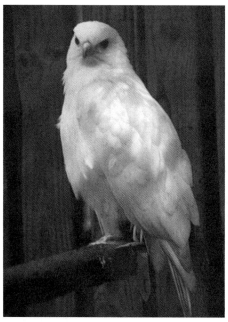

Reference Photo
Graph this reference photo with your acetate grid. Turn back to page 27 if you need a refresher course on graphing your reference photos.

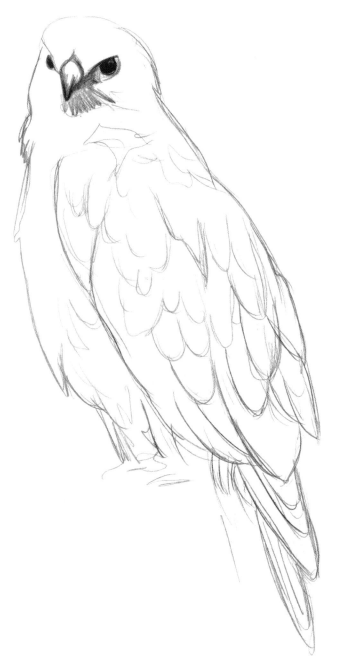

1 Create the Line Drawing

Using the graphed photo, make an accurate line drawing of the hawk. Focus on the shapes within the grid lines. When you have an accurate drawing, carefully remove the grid lines from your line drawing. Add tone to the darkest areas, such as the eyes and beak.

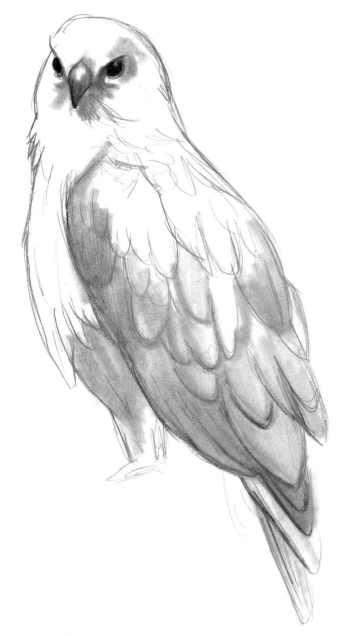

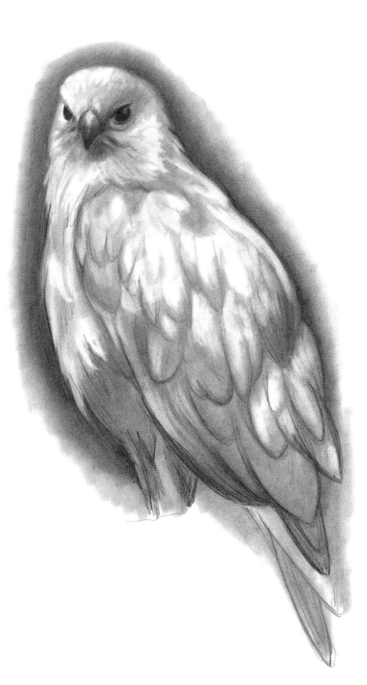

2 Add the Shadow Areas

Add and blend tone into the shadow areas of the bird to begin showing the layers of the feathers.

3 Create the Background; Blend and Lift the Lights

Add the dark background around the hawk to create and define the hawk's light edges. Blend the background well with the tortillion. Use your dirty tortillion to shade the feathers to emphasize their soft texture. Lift out the light areas with your kneaded eraser to show the illusion of random sunlight.

Draw a Duck on the Water

This drawing is very similar to the one of the swan in chapter nine. However, the patterns of the duck's feathers make it a little bit more complicated. You'll also need to remember what you learned about drawing water and combine what you learned about patterns on the owl and the individual feathers on the hawk.

The duck's markings reflect into the water, too, creating an array of light and dark patterns. Draw one shape at a time and, like a puzzle, all of the shapes will come together to create your image.

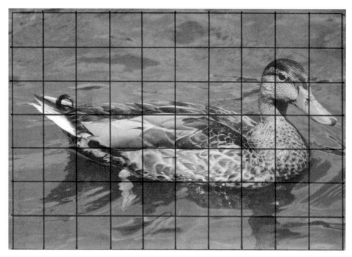

Reference Photo

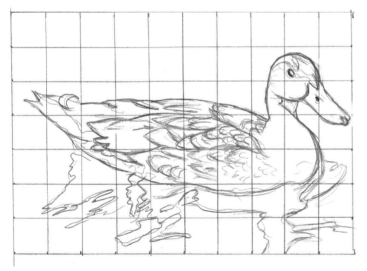

1 Create the Line Drawing

Create the grid on your paper and draw the shapes you see in each box. Treat the reflections in the water as patterns of shapes. Gently remove the grid lines with the kneaded eraser when your line drawing looks like this one.

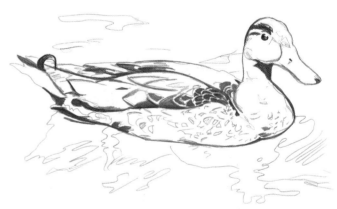

2 Create the Darks

Begin filling in small areas of dark tones with your pencil.

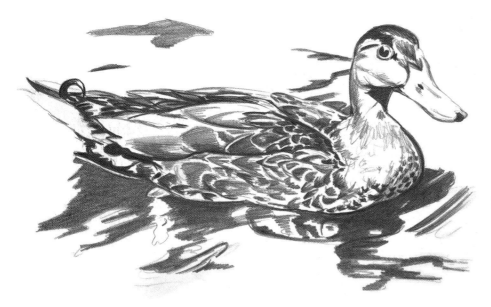

3 Slowly Fill In the Pattern Tones

There are many small patterns, so go slowly and fill them all. Assign each one a tone. Some are lighter than others.

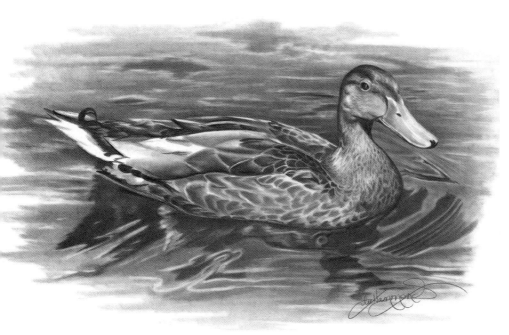

4 Blend and Deepen the Tones and Lift the Lights

Lightly blend the tones to make them appear softer, then deepen some of the darker tones again. Lift out highlight areas with the kneaded eraser.

Fill out the water with your pencil, a dirty tortillion, and a kneaded eraser. Remember, you want the water in the background to stay blurry so it doesn't detract from your subject.

things to remember

- Use shading to depict white subjects. Sometimes the more shading you use, the whiter your subject can look. Black objects depend on highlights to show form.
- A blurred background makes the main subject stand out.
- Create texture using harsh, unblended pencil lines.
- Draw feathers individually, like flower petals.
- Always look at the patterns of light and dark when drawing animals and birds.

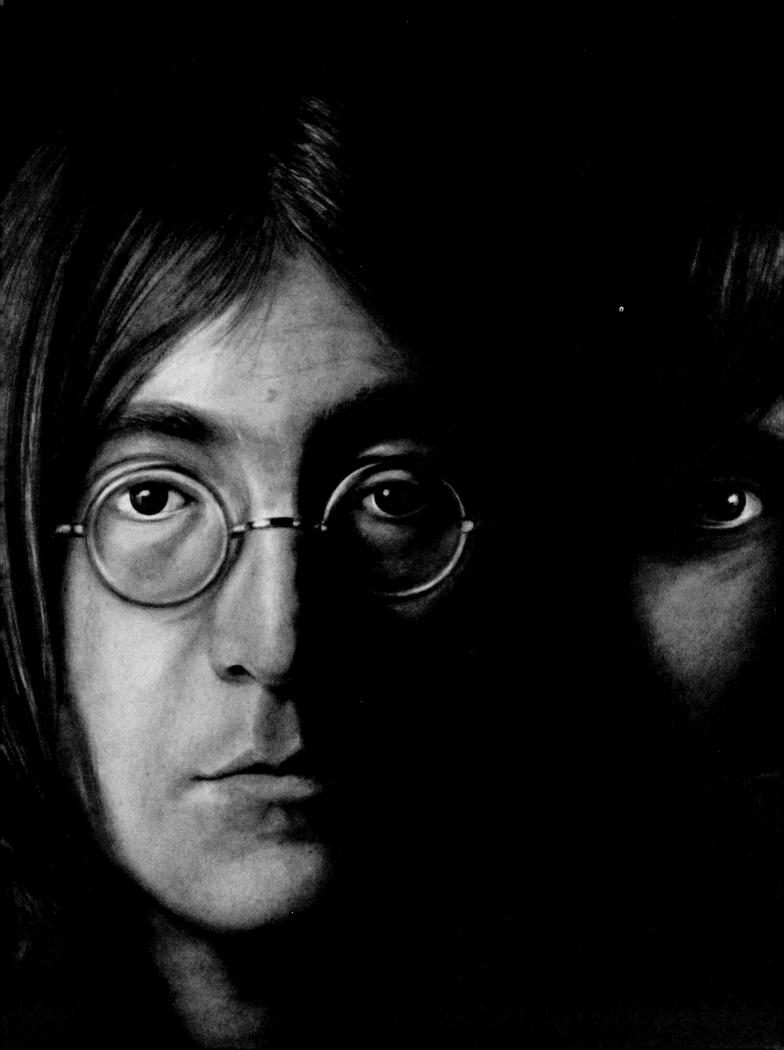

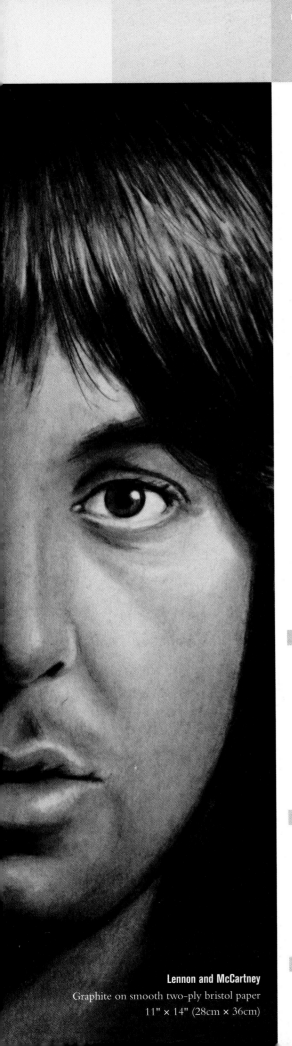

Lennon and McCartney
Graphite on smooth two-ply bristol paper
11" × 14" (28cm × 36cm)

chapter eleven

People

Many artists strive to draw people. There are few things more rewarding than capturing the spirit and personality of a human soul on a piece of paper. Adding a person to your artwork can change your art from being just a drawing of what something looks like to one that actually tells a story. Everything you've learned so far will apply to drawing people and will make the journey to portrait drawing much easier.

When I teach portrait drawing, I start just the way I started this book—with the sphere. If you look closely at a face, you will see the five elements of shading as seen on the sphere. I also emphasize my blending technique with portraiture because of the smooth contours of the human anatomy. It is the same approach you would take when rendering a smooth object like a bowl or vase.

We saw in the previous chapters how extreme lighting makes subject matter more powerful. It's the same for portraiture. Extreme contrasts create a visual impact that really catches the eye, making viewers want to see more. In this portrait of Lennon and McCartney, the center of the portrait is very dark. Their faces seem to emerge and come together out of nowhere. Each has independent lighting illuminating opposite sides, making it look as if the light is somehow forcing them together.

Draw a Nose

Before you attempt to draw a realistic portrait, it is important to practice drawing the facial features individually. When I first introduce my students to portrait drawing, I always begin with the nose.

Many people believe that the nose is one of the most difficult things to draw. Beginning artists often place a hard-edged line around the entire nose. A nose is a very gradual protrusion; because of this, there is no outline. Use gradual shading to draw the nose, much like the sphere exercise. Like drawing everything else, depicting facial features is the process of shapes, lights and darks. The five elements of shading are essential.

1 Create the Line Drawing

Begin with an accurate line drawing. Do not overdraw. The nose is made up of gradual soft edges.

2 Add the Shading

Add the areas of tone with your pencil. Refer back to the five elements of shading and the sphere. Add the cast shadow on the right side and underneath. Include reflected light around the nostril.

3 Add More Shading and Blend the Tones

Add the shading down each side of the nose. With the tortillion, blend out all of the tones until they are smooth. Leave the light going down the bridge of the nose, and be sure not to lose the reflected light around the tip and nostrils. Gently blend out the tones with the tortillion. Allow them to gently fade into the paper.

Draw a Mouth

The mouth holds much of the character of your subject. Drawing the mouth requires the same process as the nose, with a couple variations. The upper lip generally appears darker than the lower lip because it angles inward and doesn't catch the light. The bottom lip protrudes outward and does gather light.

There is a slight turn to these examples. If you measure out from the center points to the outside edges, you will see that there is more showing on the right side than the left. Your subconscious will try to straighten it and make it symmetrical. Many times this asymmetry is accurate for the angle of the face. Measure your reference photo to be sure.

Drawing a closed mouth can be quite different from drawing an open mouth. When drawing an open mouth, you have to pay special attention to the teeth. If every tooth is not accurate, it will not create a good likeness of your subject.

1 Create the Line Drawing

Draw the shapes of the lips. The upper lip resembles a flattened "M" shape.

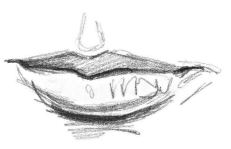

2 Add the Initial Shading and Shadow

Fill in the tone of the upper lip. Add the cast shadow below the bottom lip. Add the shadow edge to the bottom lip to create the reflected light.

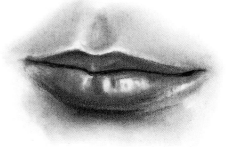

3 Deepen the Tones, Blend and Lift

Deepen the tones, adding more to the bottom lip. Blend everything with the tortillion. Lift the shine out of the lips with the kneaded eraser. Don't forget to add some shading above and below the mouth.

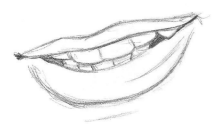

1 Create the Line Drawing

Create your line drawing as you did for the closed mouth, but make every tooth accurate to your subject from the start. Don't place a dark line between each tooth. The line should be very subtle.

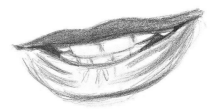

2 Begin to Add Tone

Add tone to the upper lip. Place some tone under the teeth in the corners of the mouth. This helps create the shape of each tooth.

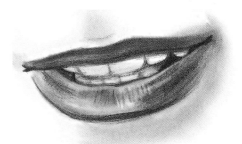

3 Deepen, Blend and Lift the Tones

Blend the upper lip for smoothness. Add some tone to the bottom lip and lift highlights with your kneaded eraser to make it look shiny. Add soft shading above and below the lips and in the corners.

Draw Eyes

Drawing eyes is difficult for many reasons: There are two of them; they are sphere shapes hidden behind layers of eyelids; you have hair and lashes to deal with; and you have moist, reflective surfaces to capture. But nothing shows more emotion and feeling than eyes.

The most important details to remember as you draw eyes are:

- The shelf or ridge created by thickness of the eyelid below the iris.
- For straight, front-view portraits, the pupil (the black spot) and the iris (the colored spot) should always be perfect circles. A circle template will help you draw them accurately.
- Place the catchlight (the glare of the light source) half in the pupil and half in the iris, even if the photo shows it differently.
- Always center the pupil inside the circle of the iris for front-view portraits.
- Represent the color of the eye with tone. Light gray represents a blue eye, while a deep gray resembles a brown eye. This example is a medium gray, which is similar in tone to the green eyes of the model.

Lee's lessons

When drawing eyes, it is very important not to outline. This is especially important around the bottom eyelid. Beginners often place a single dark line under the eye. Don't do this!

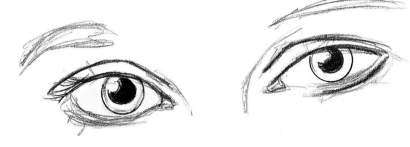

1 Create the Line Drawing

Keeping one eye width between the eyes, create the line drawing. Freehand the iris and pupil for placement and size, then use a template to make them perfect circles. Use the same size for both eyes! Leaving room for the catchlight, add tone to the pupil to make it look pure black.

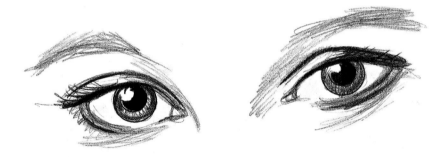

2 Fill In the Darks

Add more tone to the black of the pupil. Add tone and blending to the iris, then the dark ring around it. The iris is lighter around the pupil. Add shading inside the eyebrow shape and to the upper and lower eyelids. Use quick strokes with the pencil to taper the ends of the lines to begin believable eyelashes.

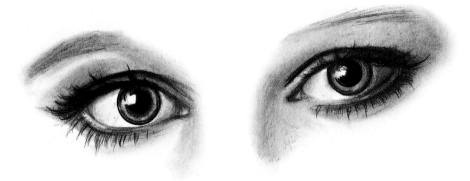

3 Finish With Blending and Lashes

Blend all your tones, add more shading where needed and blend again. Fill in the lashes. The bottom lashes come off the lower edge of the lower lid. Lashes grow in clumps, so don't individually space each lash.

Use a dirty tortillion to create the shadows of the eyes where the eye connects with the eyebrow and the nose. Use soft and gradual tones that gently fade into the white of the paper. Shade the white of the eye to make the eyeball appear round.

Draw Ears

Of all the facial features, I get the most complaints from my students when it comes to drawing ears. They can be extremely frustrating because of their structure. They are actually shapes within shapes, and it is easy to get lost as you draw.

The best way to become comfortable drawing ears is to force yourself to draw as many as possible. By repeating the process over and over, you'll commit the anatomy of the ears to memory and will know exactly what to look for when drawing them.

1 Create the Line Drawing

Begin with an accurate line drawing. An ear is made up of many interlocking shapes. It is easy to get lost, so study where each shape fits inside the other.

2 Add the Darks

Apply the dark tones with your pencil. These dark tones make areas recede.

3 Add and Blend the Tones, then Lift the Light

Blend the tones with the tortillion to create gradual curves. Since the ear is shiny, lift light areas with a kneaded eraser. The earlobe resembles a sphere. Reflected light can be seen around the edge because of the darkness behind it.

Drawing Hair

Drawing hair is not as hard as it looks. No matter what hair type you want to draw, the same drawing principles apply. Use this three-step procedure for rendering realistic hair. Practice drawing the various hair types in different stages.

1 Draw the Hair's Basic Shape.
Look for the patterns of light and dark. Begin filling the hair with pencil strokes, imitating the direction that the hair grows. Start with the darkest areas first and take your pencil lines into the light. Hair tones should be darker close to the head and become lighter toward the outside edges. Each example provided will go in a different direction according to the hair type and style. Treat each curl and layer separately.

2 Blend the Tones.
Once you've created the tones with pencil lines (this will take many layers, so don't quit too soon), blend the entire area to remove the white of the paper.

3 Lift the Lights and Darken the Darks.
Strengthen the dark areas with more pencil lines. Lift the highlight areas with a kneaded eraser that has been flattened between your thumb and forefinger into a flat razor edge. Use the same quick strokes with the eraser that you used to apply the pencil lines.

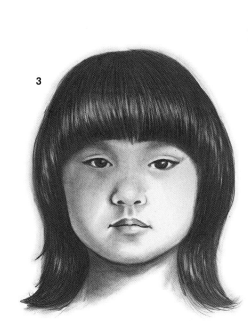

Straight, Dark Hair

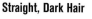

Braided Hair

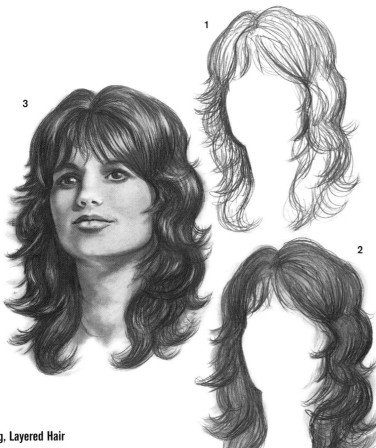

Long, Layered Hair

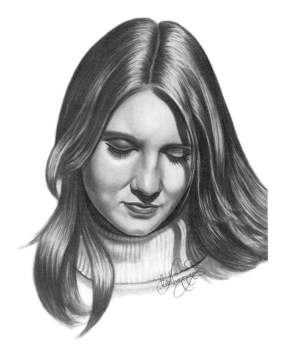

Long, Straight Hair

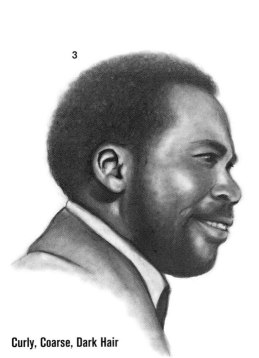

Curly, Coarse, Dark Hair

Short, Spiked Hair

145

Learn From Statues

Many of the Old Masters practiced their craft by drawing from statuary as well as living forms. The smooth, gentle contours of the body give the artist the five elements of shading in a beautiful combination of shapes. Drawing from statuary is the perfect way to practice rendering the human form without a live model.

Because the statue is all one tone, you can concentrate on the form and shadows alone and not be concerned with color. You can also use lighting to create interesting shadows that will illuminate the subtle contours of the form.

I used this statue for a model for some of my artwork while still in school. The extreme lighting makes it a perfect example, depicting the subtle blending required for achieving smooth tones.

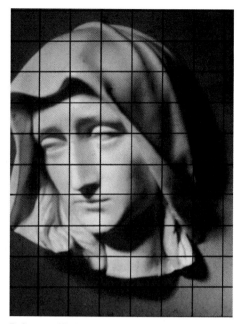

Reference Photo

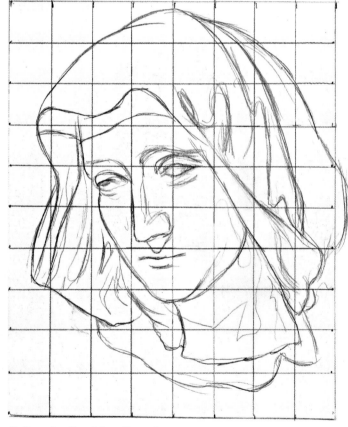

1 Create the Line Drawing

Based on the reference photo, lightly create a grid on your drawing paper and create the shapes you see in each box. Carefully erase the grid lines when you are sure of your accuracy.

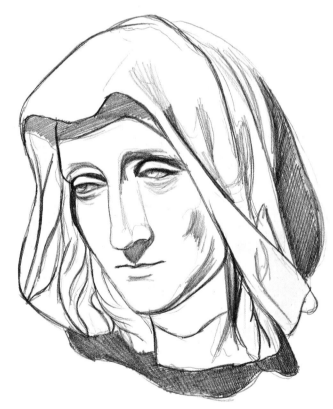

2 Fill In the Darks

Look for the darkest areas and fill them in. On this example, the cast shadows form the darkest areas.

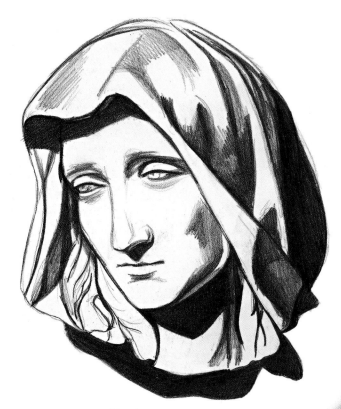

3 Develop the Shadows

Continue developing the tones and cast shadows. Deepen the tones of the cast shadows. Notice how adding the cast shadow on the neck helps create the edge of the jawline with reflected light.

4 Deepen and Blend the Tones

To finish the drawing, blend all of the tones, then smooth them out with a tortillion. Deepen anything that needs to be darker, then blend it again. Add the shadows around the figure to make the face look as if it is glowing in the soft light.

Practice Drawing People Using Statues

Don't stop with just one statue drawing. Look for other statues to practice on. They are wonderful things to draw, mostly because of the way the light reflects off of their carved surfaces. Everything on the statue is more dramatic and defined. The lighting becomes extreme due to the hard surfaces, which give you clear light and shadow to capture. Their smoothness combined with extreme lighting gives you a perfect opportunity to capture the five elements of shading. And don't settle for just capturing their faces! Statues give you the perfect opportunity to practice drawing the whole figure.

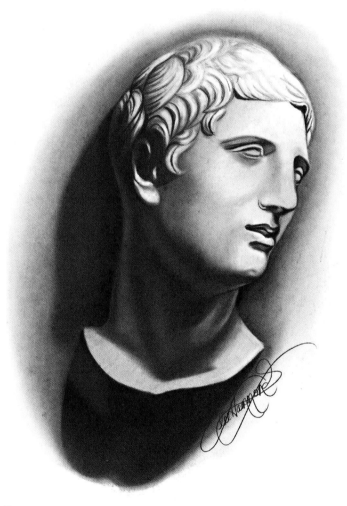

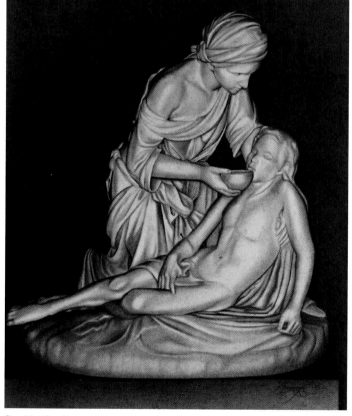

Combination Lessons
A friend of mine went to Italy and brought back magnificent photos of some of the ancient sculptures and statues. This sculpture combines lessons on drawing creases and folds, portraits and the figure all in one! Notice all the darks and lights in this drawing.

Extreme Lighting Shows Off Shadows and Light in Statues
The deep shadows on the left side create subtle tonal changes in the dark areas. Reflected light is apparent all around the edges and along the jawline.
 On the right side, in the full light area, detail is actually lost in the bright light. The dark background helps describe the edge of the face and head. Pay attention to details such as these as you look for statues to draw.

Draw a Portrait

Let's take all the information we learned in the previous exercises and create an entire face. Use the graphed photograph as your guide. Lightly draw the same number of squares on your drawing paper as you see here. Then draw the shapes you see in each box.

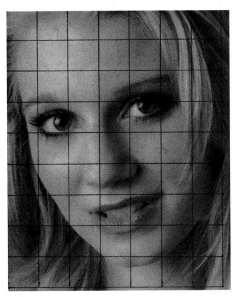

Reference photo

photo by Brandon Vogts

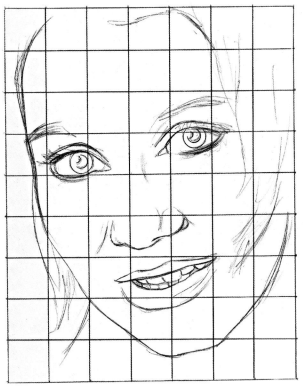

1 Create the Line Drawing

This is what your drawing should look like. When you are happy with the accuracy of your work, gently remove the grid lines with your kneaded eraser.

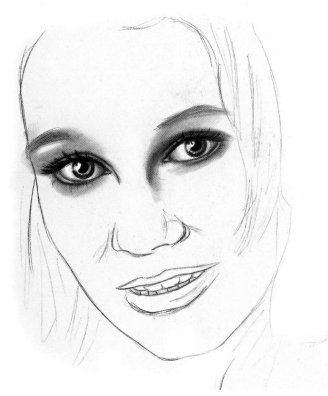

2 Begin With the Eyes

Refer to the step-by-step demonstration on page 142 and draw the eyes first. Don't move to the nose until you are happy with the quality of the eyes.

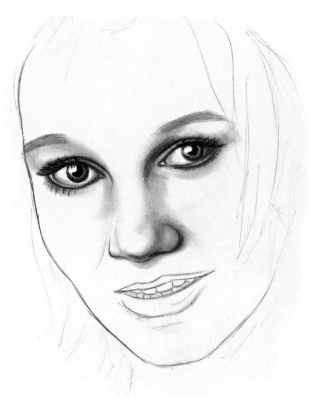

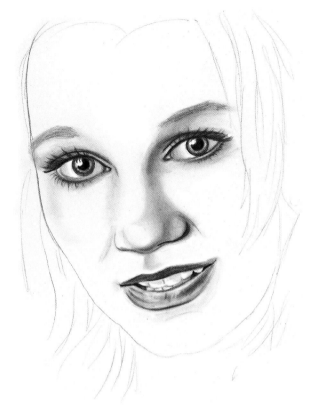

3 Create the Essential Shadows on the Nose

Refer to the step-by-step demonstration on page 140 to begin shading there. Leave the highlight areas white at this point.

4 Add Tone to the Mouth Area

Continue the portrait by adding tone to the mouth area as shown. You can also begin to add tone to the shadow edges along the side of the face.

5 Add and Blend the Tones on the Face

Add the shading and blending to create the skin tones to bring the portrait together. Concentrate on the light and dark tones you see in the reference photo. Draw the hair along the side of the face with very quick, tapered strokes, then blend your strokes with a tortillion.

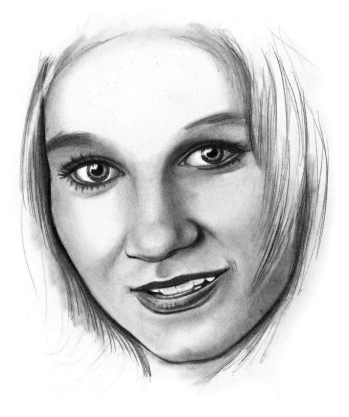

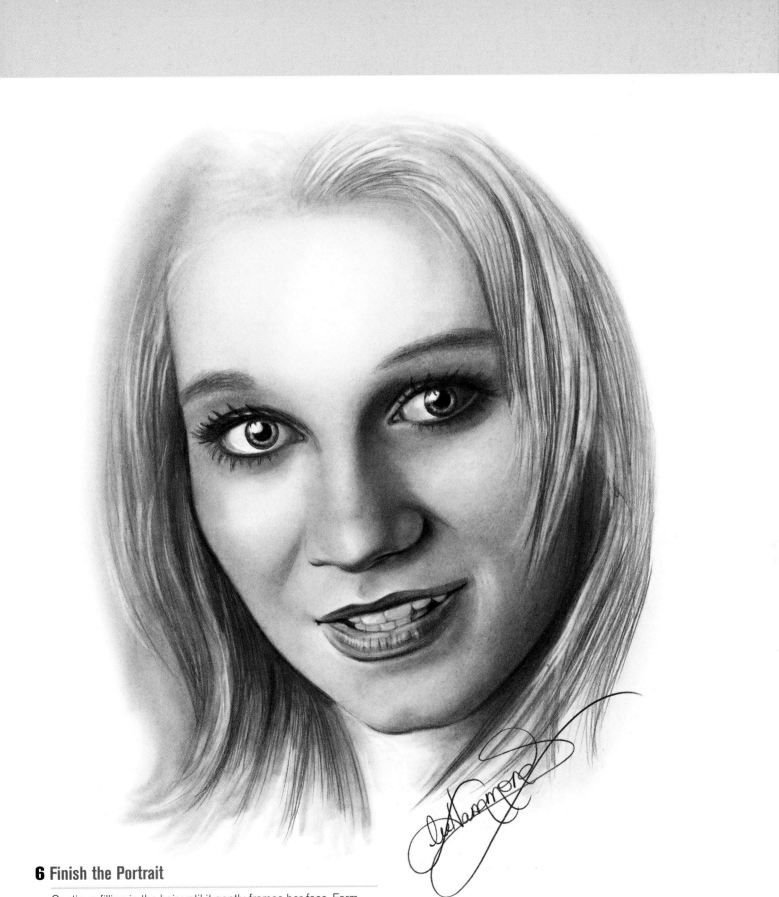

6 Finish the Portrait

Continue filling in the hair until it gently frames her face. Form your kneaded eraser into a point to lift out highlights from her hair. This will make it appear blonde.

Looking at the reference photo, continue to add and blend tones until you achieve this smooth look.

Create Muscle Tone With Shading

The human form offers many curved areas that create gradual transition in tone. It is no wonder that artists over the centuries have used it as subject matter for their artwork. The body, with its subtle changes in form, gives us a wonderful opportunity to create form through blending. This step-by-step of a torso will give you practice drawing soft curves and edges.

1 Create the Line Drawing

Use this as a guide to achieve an accurate line drawing. Draw a light grid on your paper, then draw the shapes you see in each box. Notice how simple lines represent the muscle shapes.

2 Remove the Grid and Place the Darks and Shadows

Gently remove the grid from your paper, leaving a border box around the subject. Begin placing the dark areas. In this drawing, the shadows are very extreme. The darkness accentuates the highlight area. Fill in the background along the left side to create the light along the edge of the body. Fill in the cast shadow on the shoulder and create the shadow down the side of the arm.

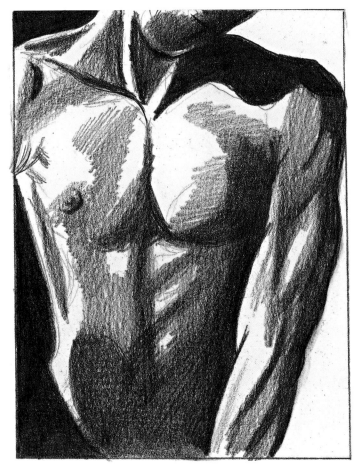

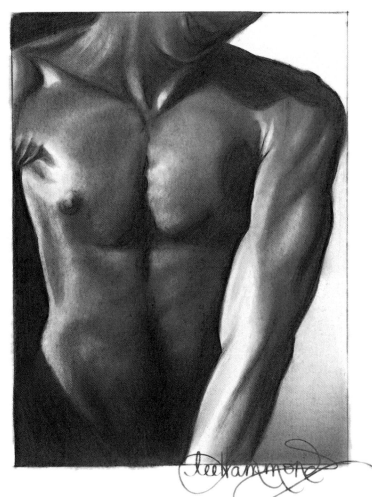

3 Use Shading to Show Curves

Shade in the tones to create the shapes and curves of the muscles. Look for the five elements of shading as you go.

4 Blend and Deepen the Tones, Lift the Highlights

Blend your tones with the tortillion, then deepen the dark areas. Make sure that the tones gradually fade into one another for subtle curves. Lift the highlight areas with the kneaded eraser. Go down into the lower right side of the border box and blend up from dark to light. This gives the impression of distance in the background.

demonstration

Draw a Sitting Figure

Lifelike drawing requires more than capturing every detail of the face. In this drawing, the essence of my daughter, LeAnne, is captured while most of her face is hidden in the shadows. While a photograph such as this may be disappointing, the artwork you can produce with it is stunning. Your photos will take on a different light as you learn to see them through the eyes of an artist.

Using the graphed photo, draw an accurate line drawing of LeAnne. See her face area as patterns of light and dark. Your subconscious will try to interfere and tempt you to draw things you cannot see! Discipline yourself to see and draw just the shapes instead. As you complete this step-by-step, remember what you've learned in previous chapters. You'll be using what you know about how to create metal and wood surfaces, the five types of folds, hair and the five elements of shading. This is when it all comes together!

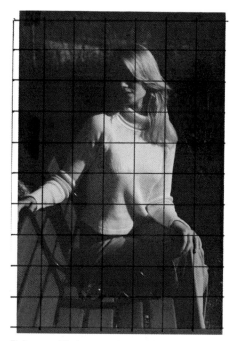

Reference Photo

1 Remove the Grid Lines and Add Tone to the Darkest Areas

Carefully remove the grid lines from your line drawing. Begin with the darkest areas, adding tone to the eyes and shadow areas. See and draw the shapes, not details!

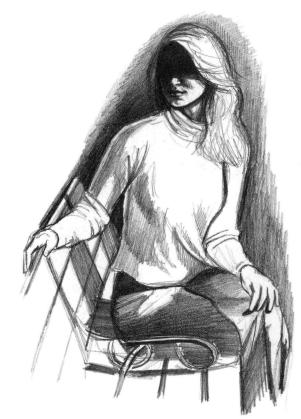

2 Fill In the Dark Forms and Shadows

You can see how adding the dark background helps create and define the light edges of the drawing. Fill in the shadow and form shapes from your line drawing. At this stage it still looks somewhat like a rough sketch.

3 Deepen the Tones, Blend and Lift the Highlights

Deepen the tones and blend to create smoothness and depth.
Be sure to include the five elements of shading in the drawing.
Look at the edges and curved areas to see the reflected light.
Notice the coil folds around LeAnne's arms.

Create the texture of the ribbed sweater with light pencil lines
following the curves and contours of her body to add additional
form. Use the kneaded eraser to lift out the light areas and to give
the illusion of random sunlight and additional texture. Use the
kneaded eraser to lift extreme highlights out of her hair as well
as the wrought iron of the park bench.

Use Your Photo Album to Capture Entire Scenes

This is where the fun really begins, by combining all of your drawing skills to create an entire pictorial scene. Your photo album is a storehouse of subject matter. What lucky people we are to be artists and see the potential!

Look for photos with dramatic and interesting shading and shadows. You saw in previous chapters how extreme lighting makes the subject matter more powerful. Extreme contrasts create a visual impact that really catches the eye. If you have a photo that you wish had more contrast, add it yourself! There's nothing wrong with adjusting things—that's an artist's license.

Don't be afraid of the small details. Embrace them! It's the details that enhance your artwork and capture the little memories, which we ordinarily would forget.

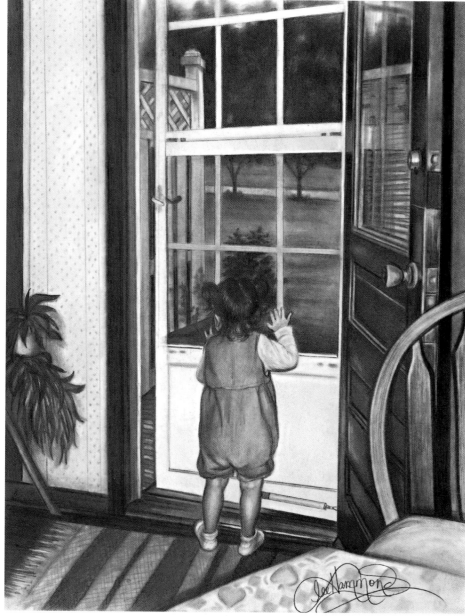

Caitlynn
Graphite on smooth two-ply bristol paper
14" × 11" (36cm × 28cm)

Look for Photos With Everyday Detail

This is a drawing of my granddaughter Caitlynn when she was two. She wanted to go outside and play with the big kids and nearly escaped. Notice the depth created by drawing the yard in the background. The white screen door contrasts against the background, pushing the darks into the distance.

The small details and textures are what make this piece. When you've got this much detail to cover, it's best to take one area at a time. There is the wood grain of the doorjamb, the chair and the open door. There is the texture and fringe of the throw rug. You can see the wood slats of the deck outside the door and the horizontal blinds through the window of the door. And don't forget the trees and bushes in the background, as well as the lattice of the privacy fence and the pattern on the wallpaper.

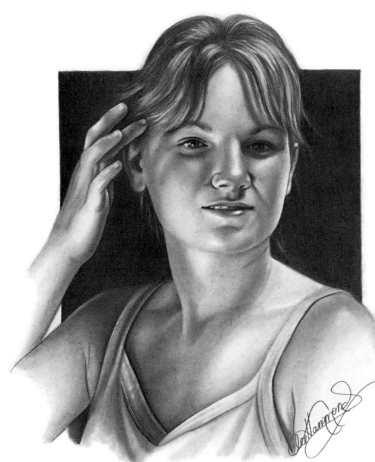

Don't Be Afraid to Alter the Photo

Be bold as you use your new skills to improve the photos you draw from. In this portrait of Shelly, it was the extreme lighting that caught my eye. We were actually inside a teepee with sunlight coming in from the small opening at the top. Her hand gesture makes the entire pose look interesting.

I added a border box in this drawing to capture the darkness of the background. This technique leads your eye to the center, making the subject the entire focus. I could have let the dark tones go clear to the edge of the paper, but too much darkness could have overpowered her face.

Shelly
Graphite on smooth two-ply bristol paper
14" × 11" (36cm × 28cm)

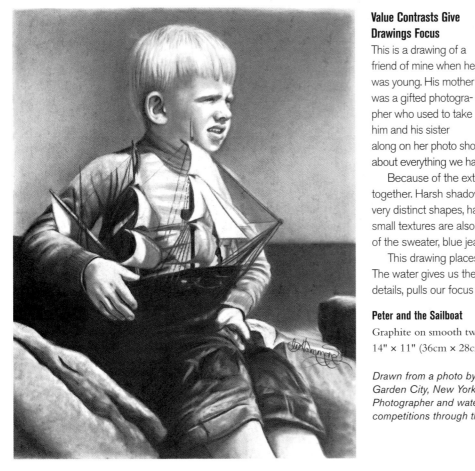

Value Contrasts Give Drawings Focus

This is a drawing of a friend of mine when he was young. His mother was a gifted photographer who used to take him and his sister along on her photo shoots. This drawing is a perfect combination of just about everything we have covered.

Because of the extreme values, the shapes of dark and light come together. Harsh shadows are combined with extreme highlights, creating very distinct shapes, hard edges and patterns. Because of the lighting, small textures are also made to stand out. Just look at the subtle textures of the sweater, blue jeans and his hair.

This drawing places the human element together with a nature scene. The water gives us the illusion of distance while the sailboat, with its small details, pulls our focus to the center of the drawing.

Peter and the Sailboat
Graphite on smooth two-ply bristol paper
14" × 11" (36cm × 28cm)

Drawn from a photo by Janet Dibble Wellenberger:
Garden City, New York, 1916-2001
Photographer and watercolor artist; also a teacher who won numerous competitions through the Nassau County (NY) Camera Club

Index

The best in drawing instruction comes from North Light Books!

Bert Dodson's successful method of "teaching anyone who can hold a pencil" how to draw has made this tome one of the most popular, best-selling art books in history—an essential reference for every artist's library. Inside you'll find a complete system for developing drawing skills, including 48 practice exercises, reviews, and self-evaluations.

ISBN-13: 978-0-89134-337-0
ISBN-10: 0-89134-337-7, paperback,
224 pages, #30220

Lee Hammond makes drawing birds with colored pencils easy and fun! She provides guidelines for creating depth and realism, along with step-by-step techniques for rendering the fine details of a bird's anatomy, color, markings, feet and feathers.

ISBN-13: 978-1-58180-149-1
ISBN-10: 1-58180-149-1, paperback,
80 pages, #31897

A sketchbook journal allows you to indulge your imagination and exercise your artistic creativity. Let Claudia Nice provide you with invaluable advice and encouragement for keeping your own. She reviews types of journals along with basic techniques for using pencils, pens, brushes, inks and watercolors to capture your thoughts and impressions.

ISBN-13: 978-1-58180-044-9
ISBN-10: 1-58180-044-4, hardcover,
128 pages, #31912

Clem Robins shows you how to render accurate human figures in the elegant style of the old masters. Distilling his lifetime of experience into a complete figure drawing course, Robins provides special step-by-step guidelines for drawing heads, hands, hair, and feet. You'll also learn how to draw from life, transforming what you see into realistic, classically rendered images.

ISBN-13: 978-1-58180-204-7
ISBN-10: 1-58180-204-8, paperback,
144 pages, #31984

Discover the limitless creative possibilities of colored pencils! Janie Gildow shows you how to mix colored pencils with watercolor, pastel, acrylic, ink and more. Gorgeous galleries, inspirational art and 24 step-by-step demonstrations showcase a stunning variety of creative combinations.

ISBN-13: 978-1-58180-186-6
ISBN-10: 1-58180-186-6, hardcover,
144 pages, #31956

This complete course in drawing focuses on the clothed person. Author Barbara Bradley takes a friendly approach to the fundamentals of drawing people—proportion, perspective and value. You'll also learn how to draw different clothing, how you can use folds in your drawings, and how to draw clothing on people. Included are tips for drawing heads and hands accurately and special instructions for drawing children.

ISBN-13: 978-1-58180-359-4
ISBN-10: 1-58180-359-1, hardcover,
176 pages, #32327

These books and other fine North Light titles are available from your local art & craft retailer, bookstore or online supplier.